Heart tattoo designs

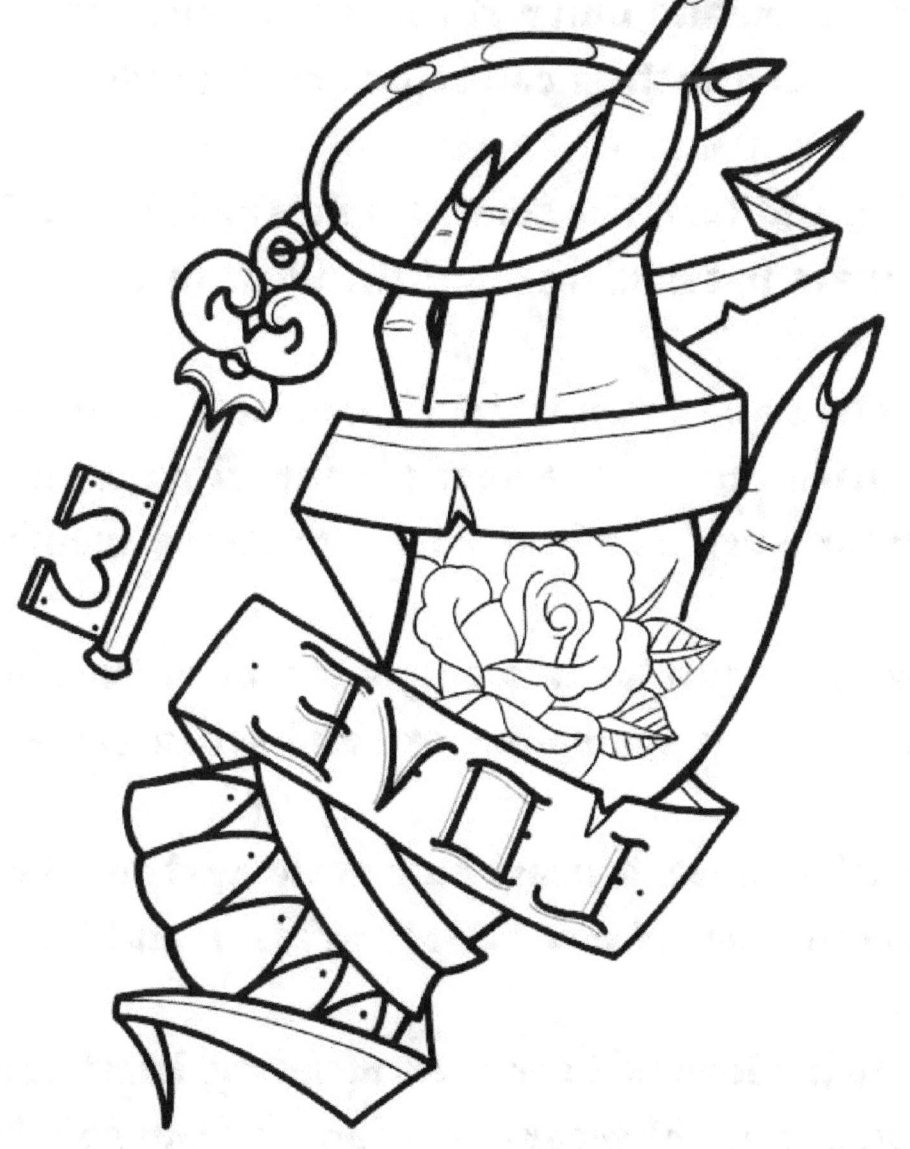

Heart tattoos have a wide and diverse meaning that goes beyond simple love and passion:

Infinite love: The heart is a symbol of love, connection and the deepest feelings. Heart tattoos often represent eternal and unconditional love.

Unity of life: In some cultures, the heart symbolizes the centralization and unity of life. Anatomical or bleeding heart tattoos can represent this idea.

Passion and lust: For some people, the tattooed heart symbolizes passion, lust and the most intense desires.

Connection and Friendship: Linked heart or half heart tattoos often represent a special connection with another person, such as a best friend or family member.

Self-love: Heart tattoos in a single stroke or in colors other than red can symbolize love and self-acceptance.

Emotional balance: A heart on a scale next to a brain can represent the balance between reason and feelings.

In short, while love is a common meaning, heart tattoos can have a wide range of meanings ranging from spirituality to expression of personal identity.

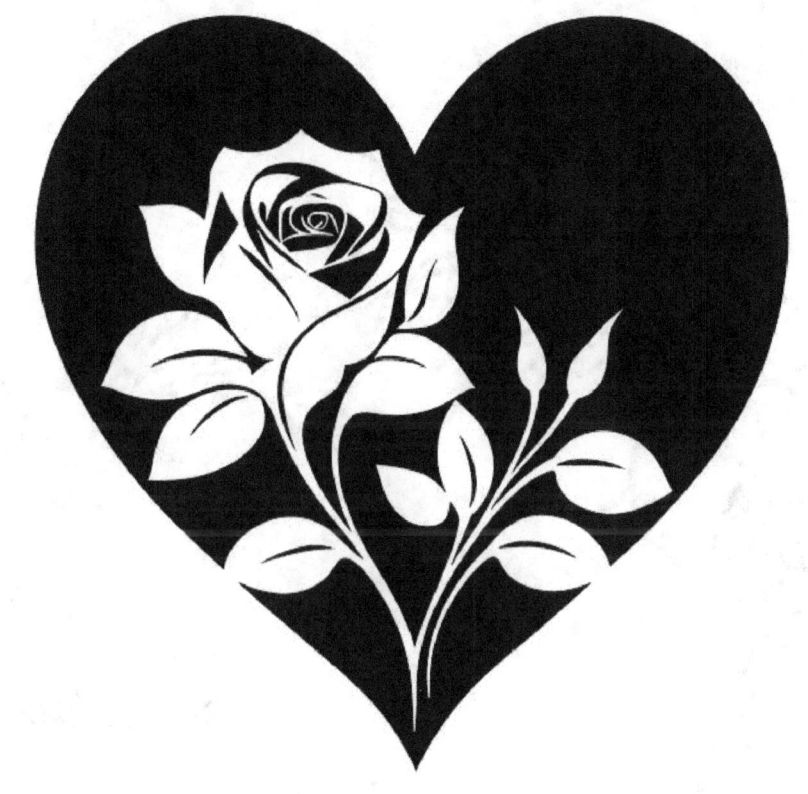
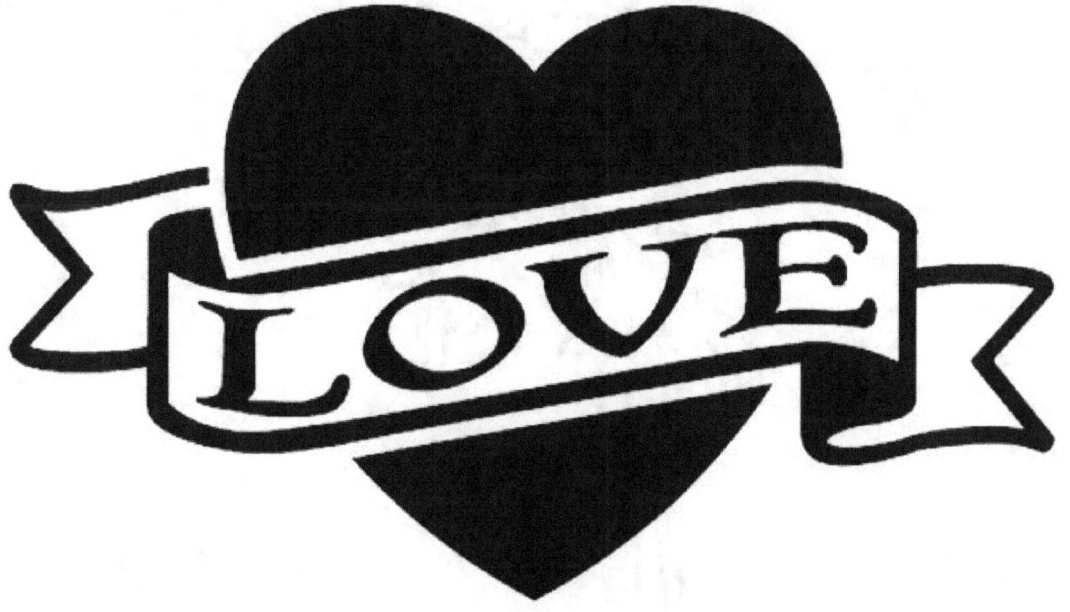

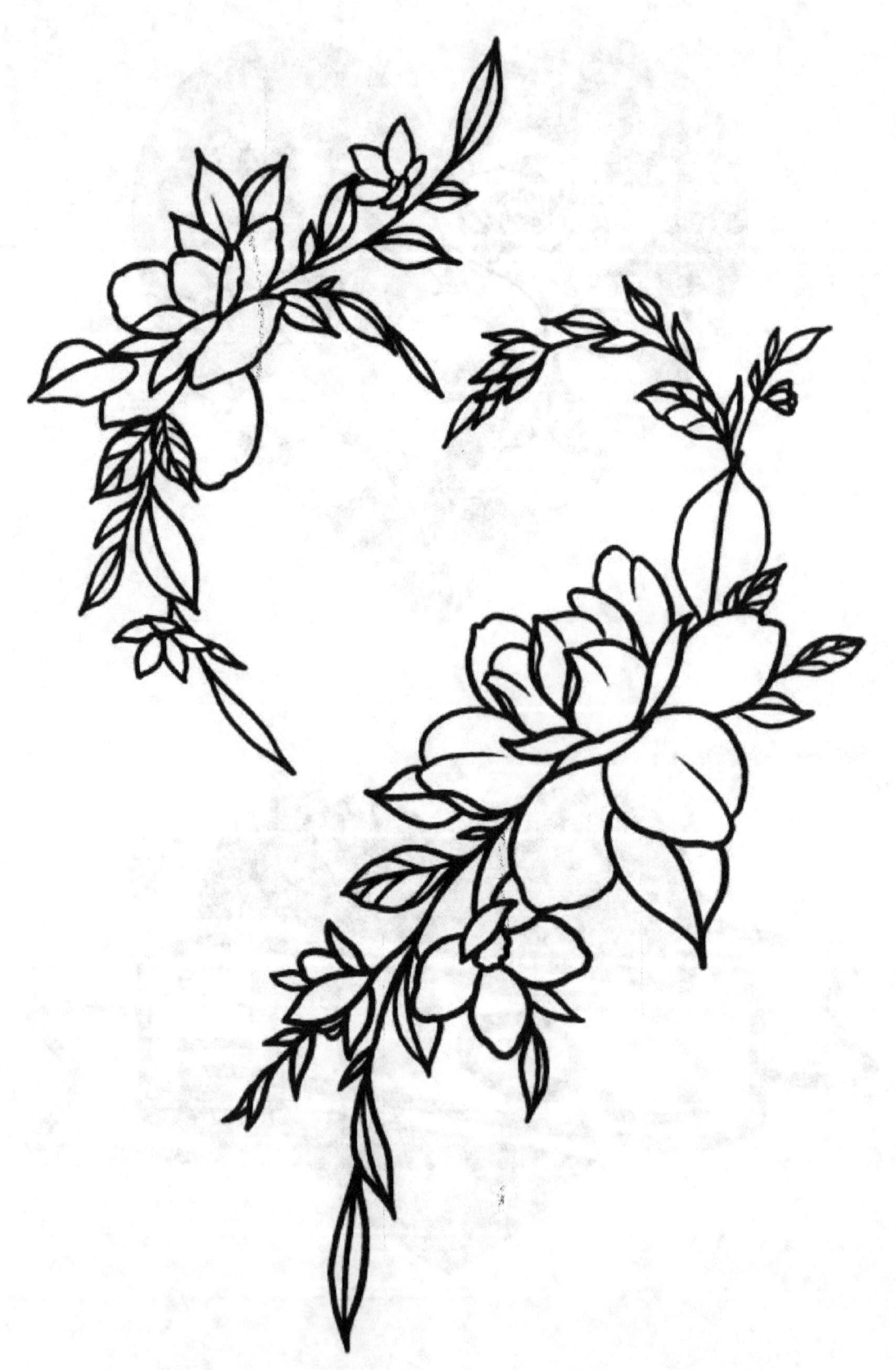

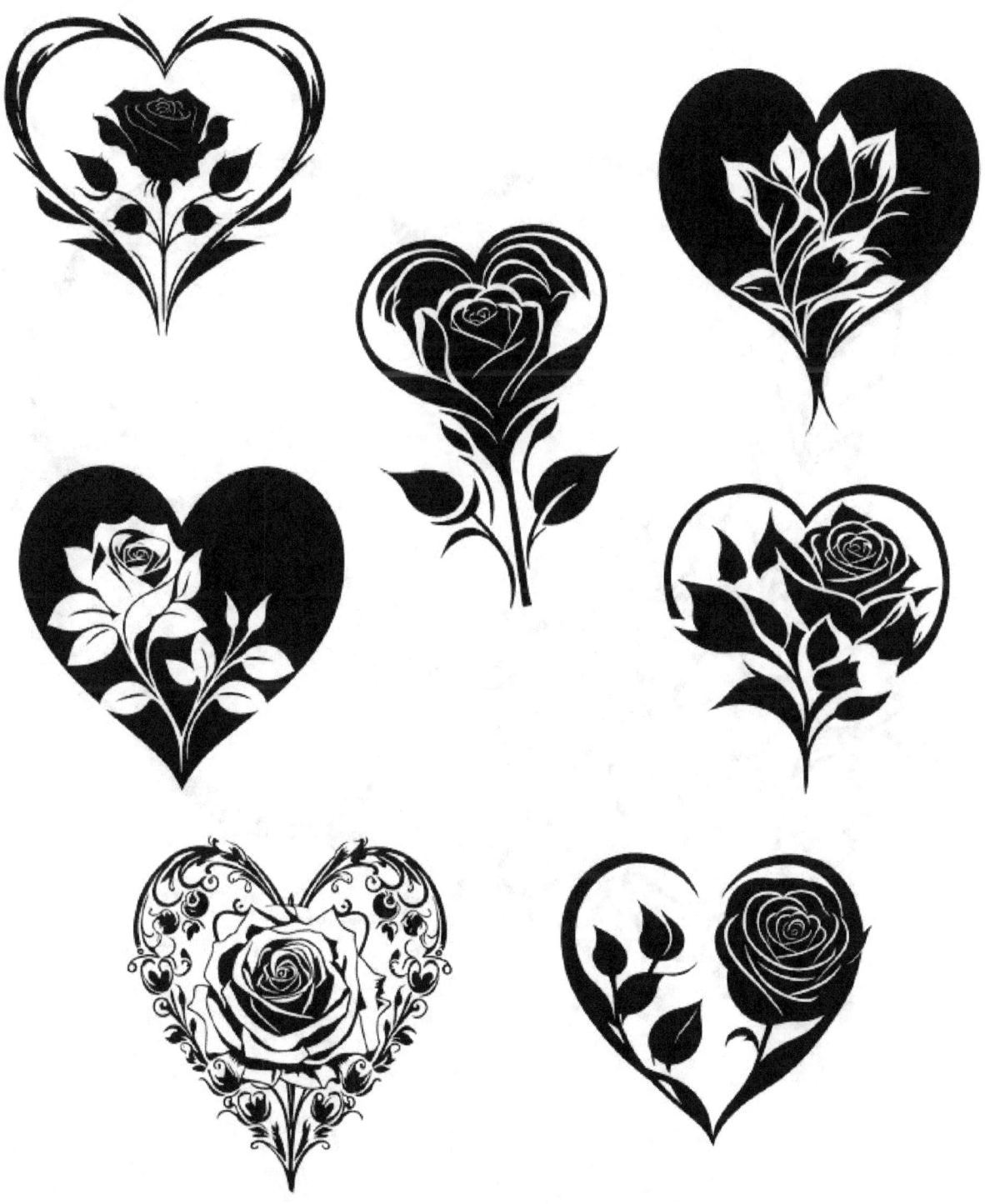

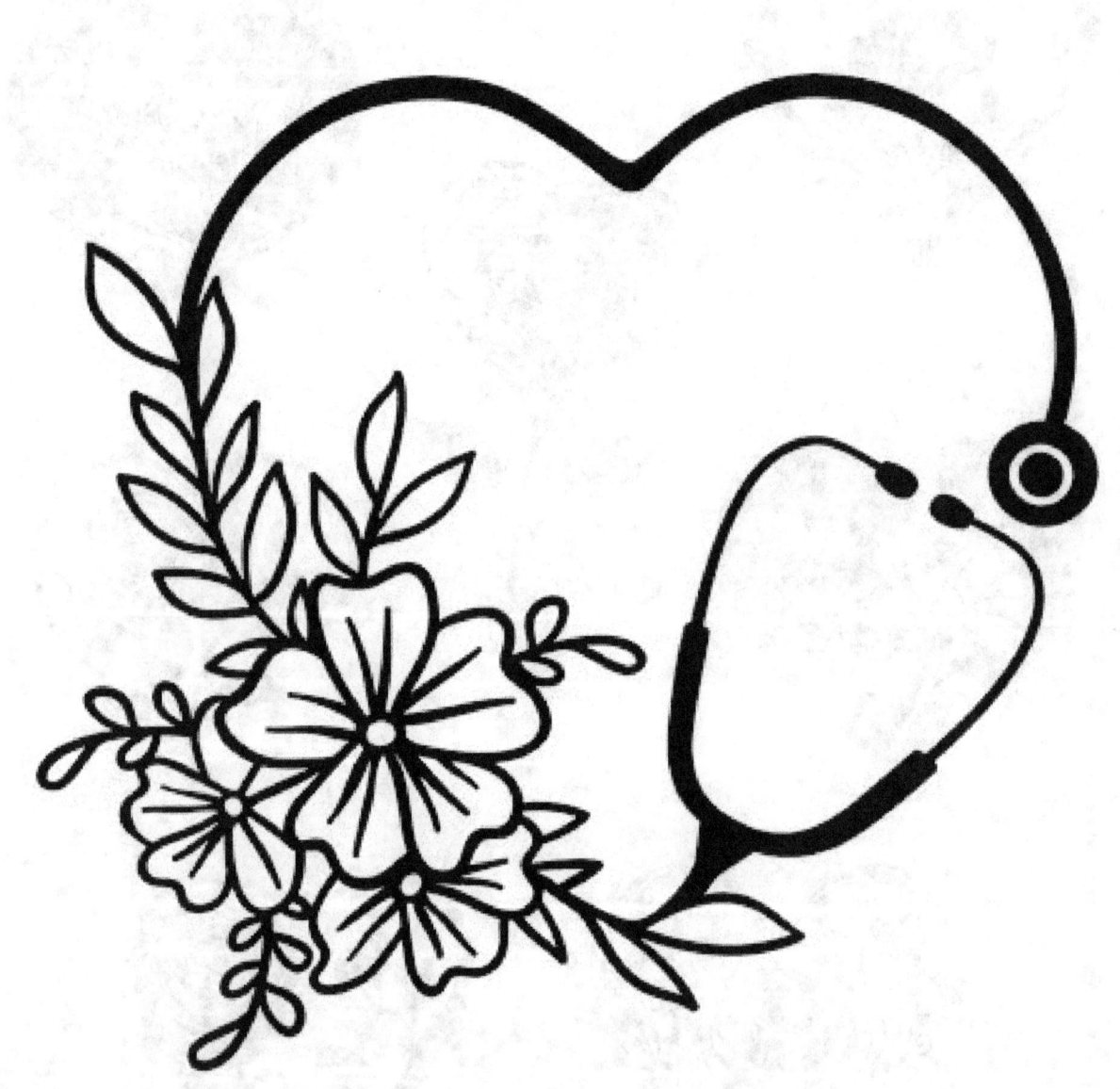

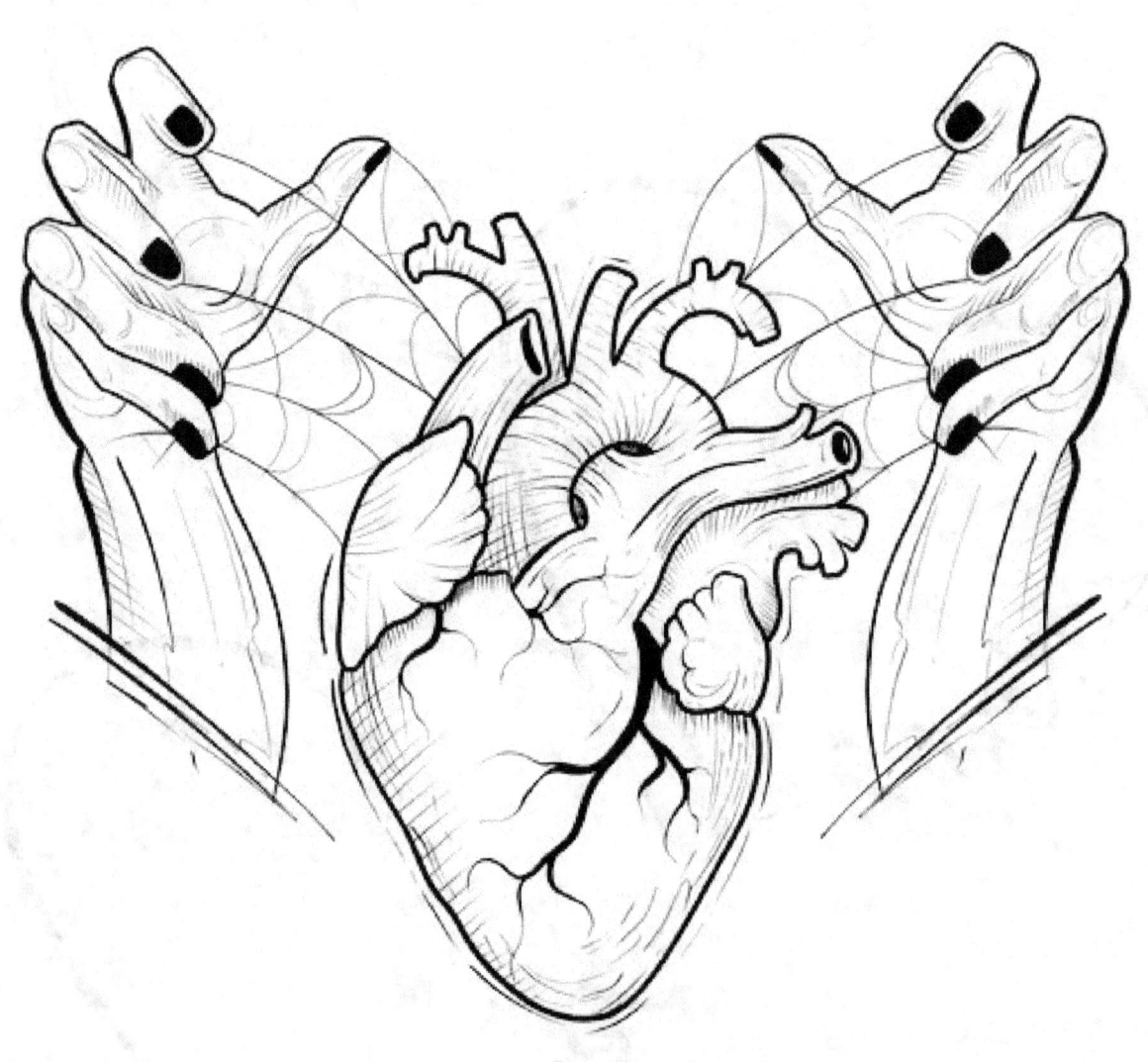

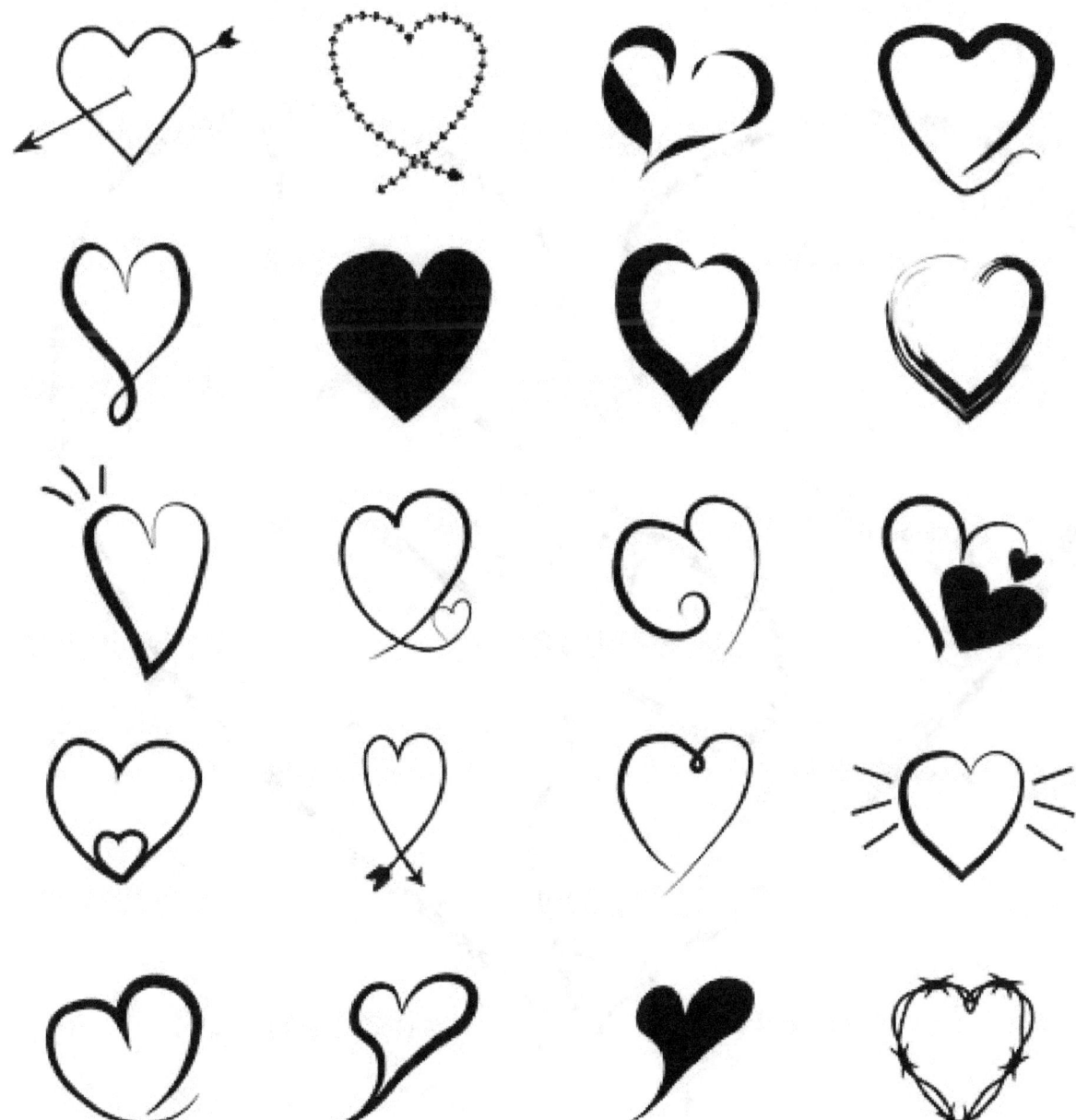

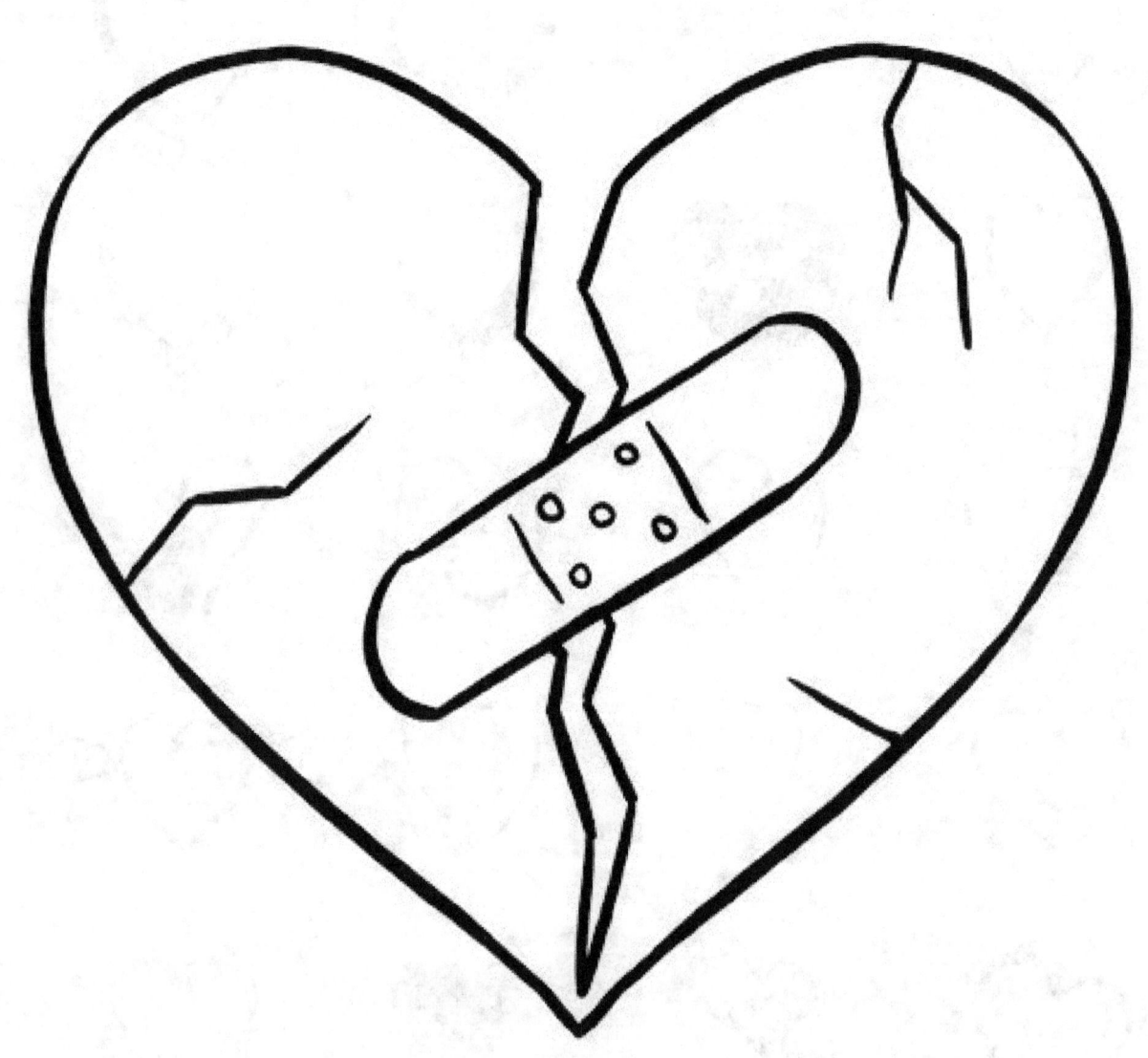

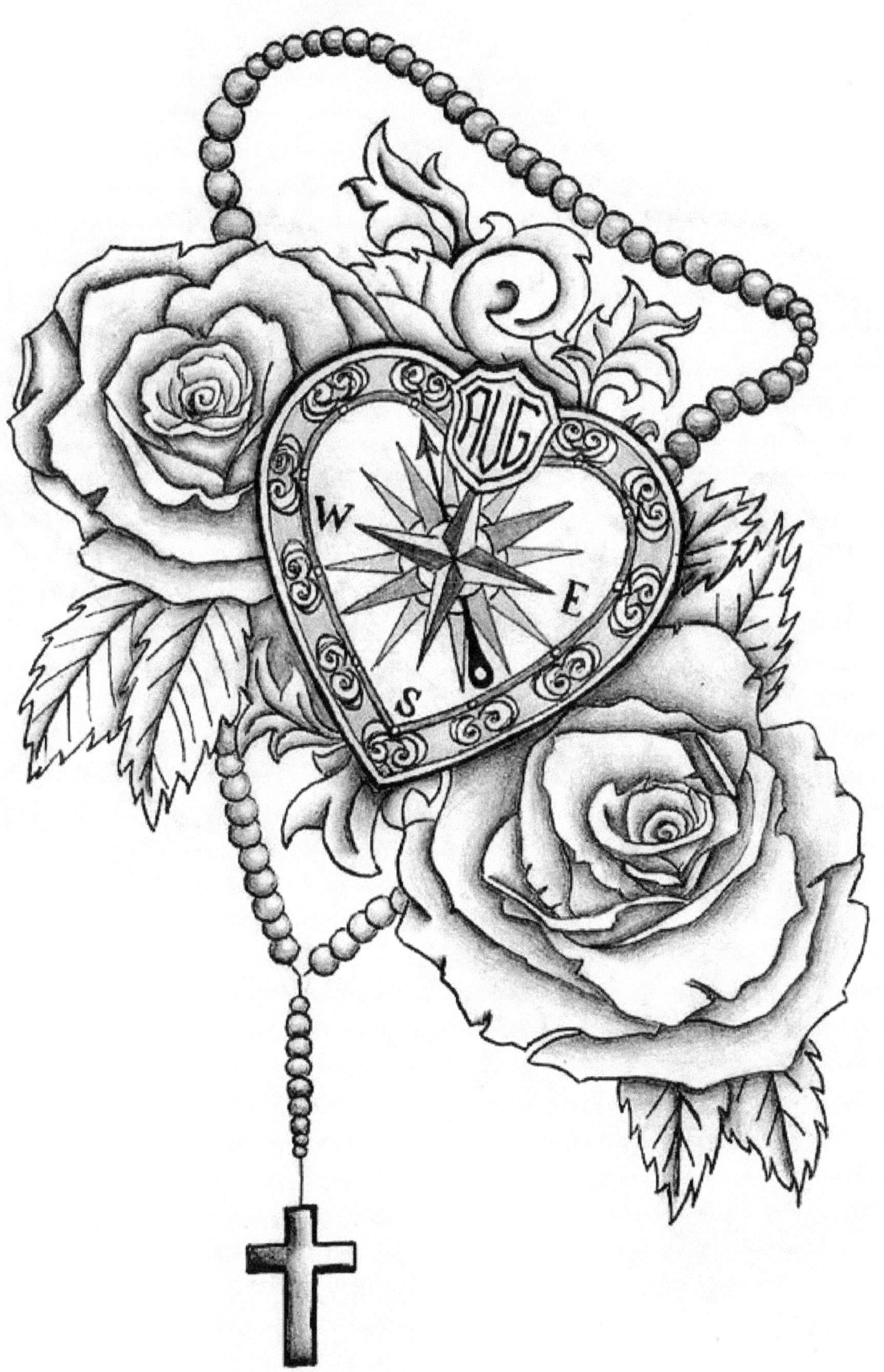

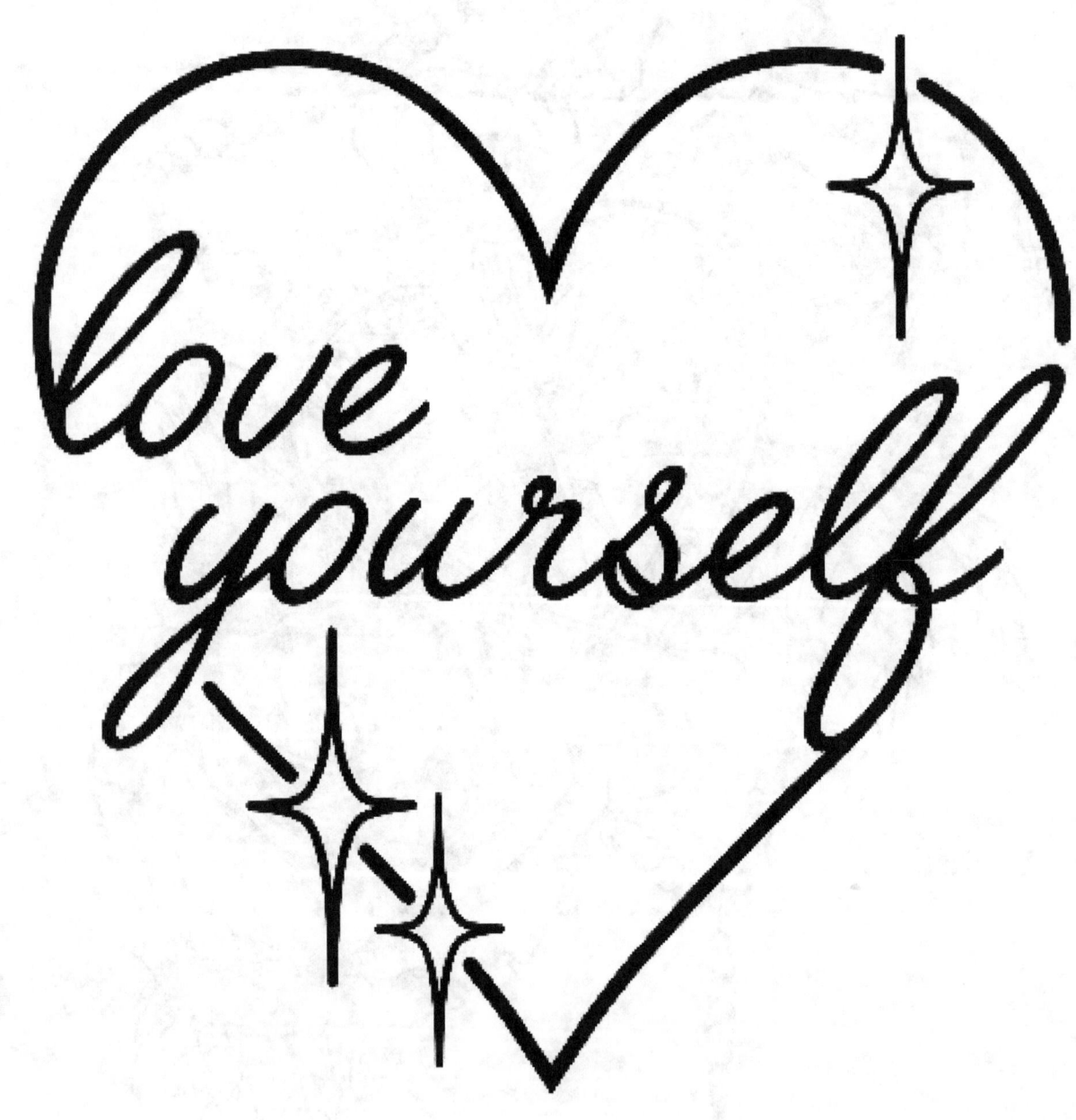

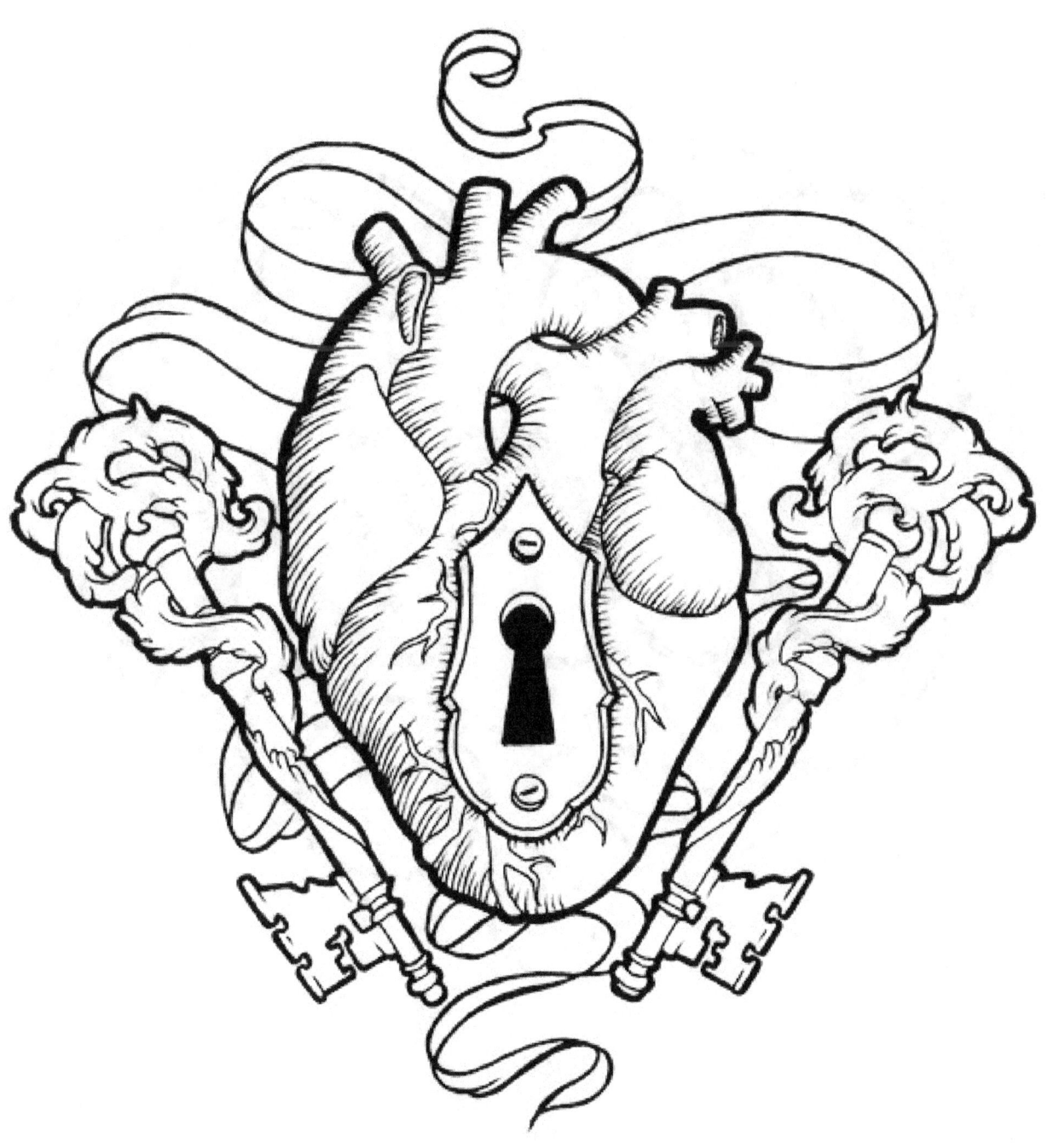

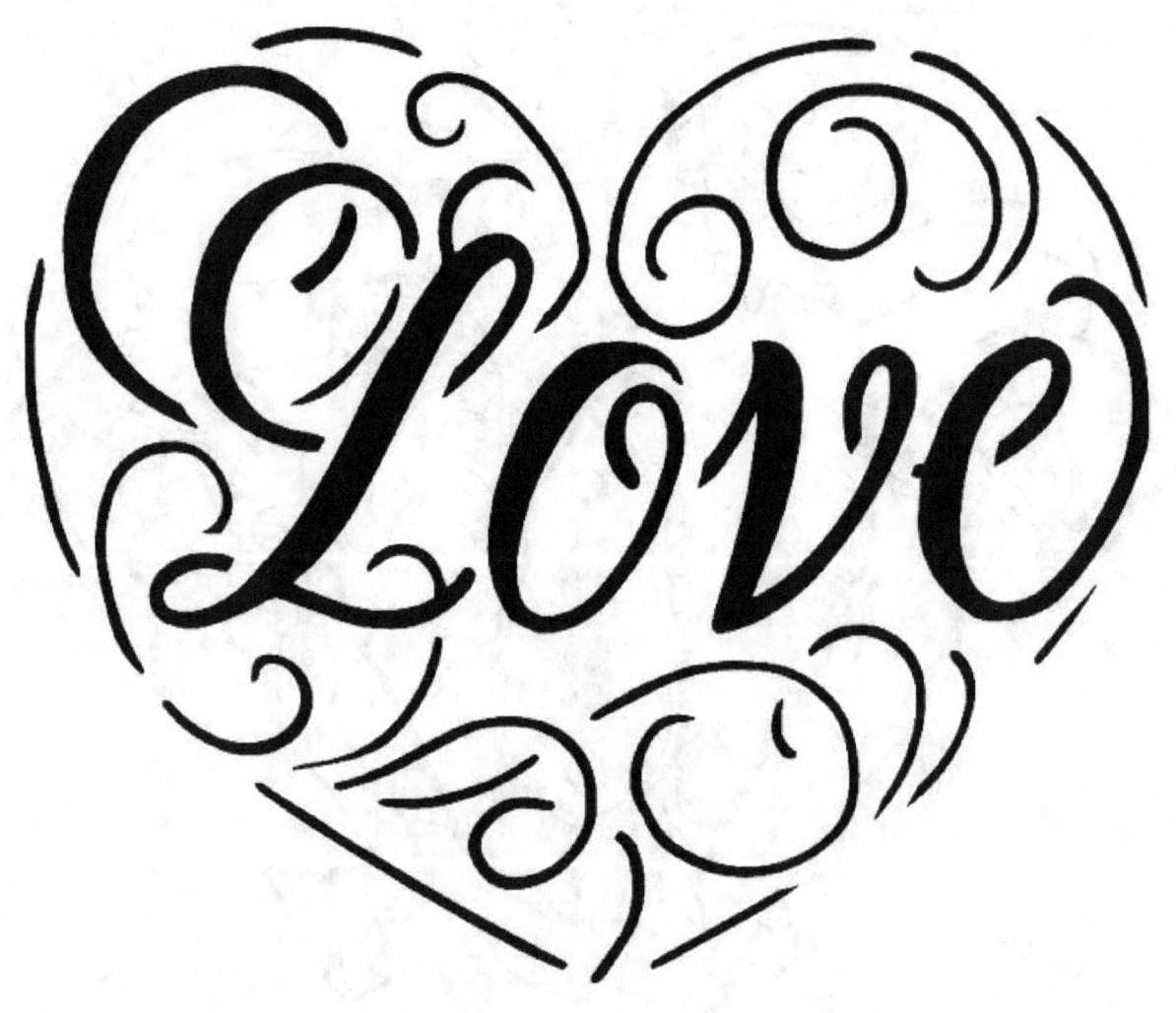

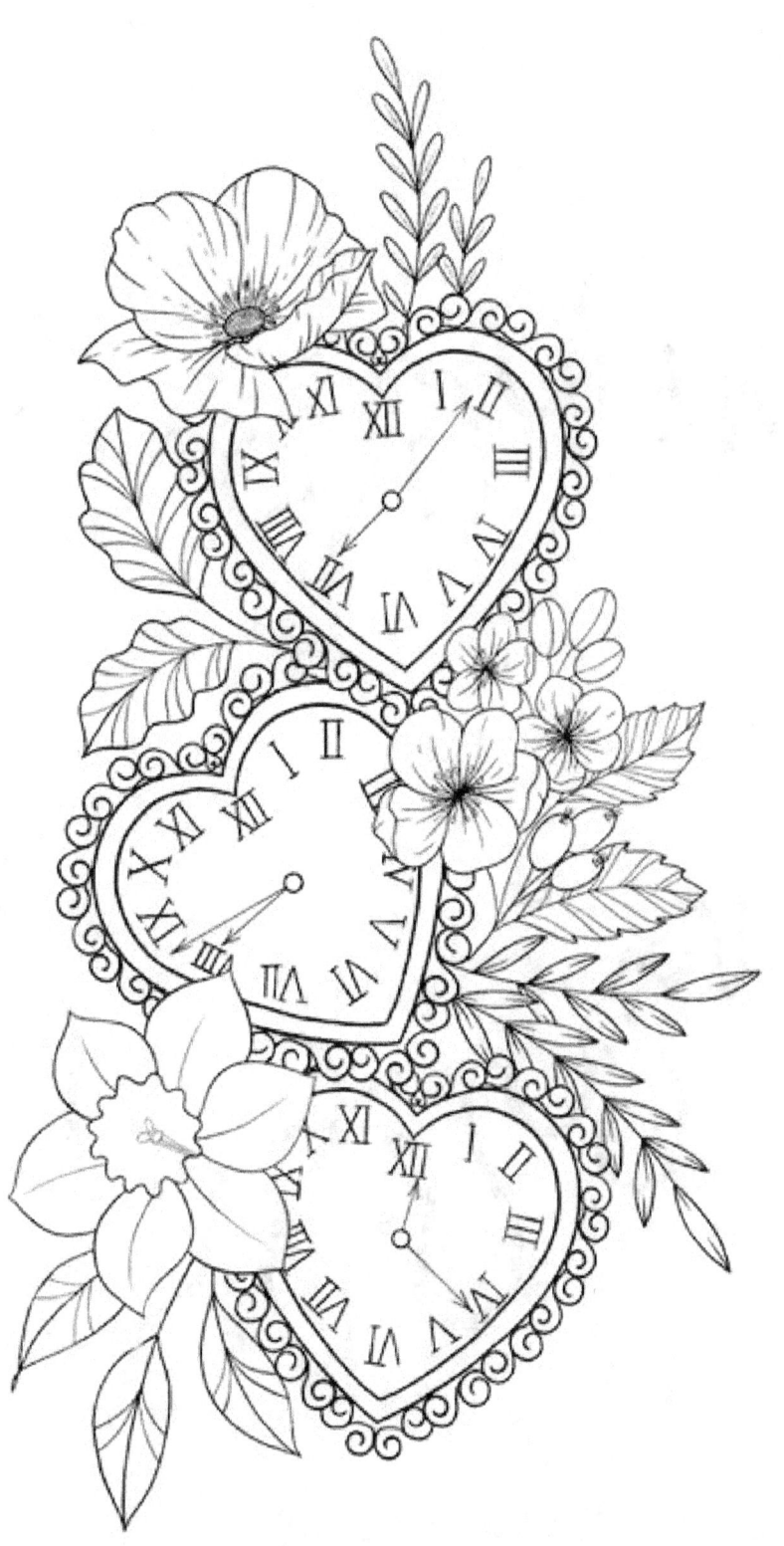

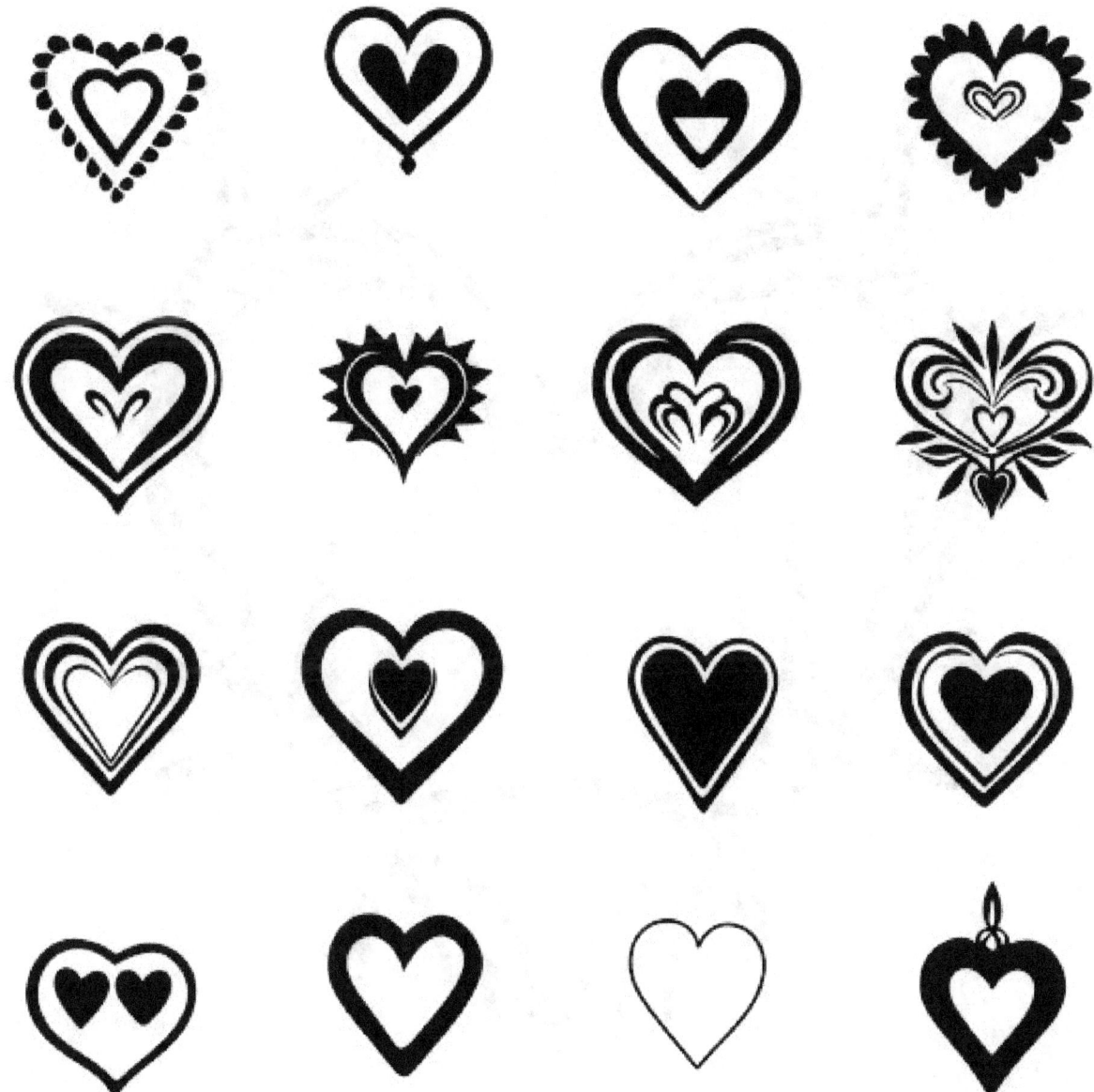

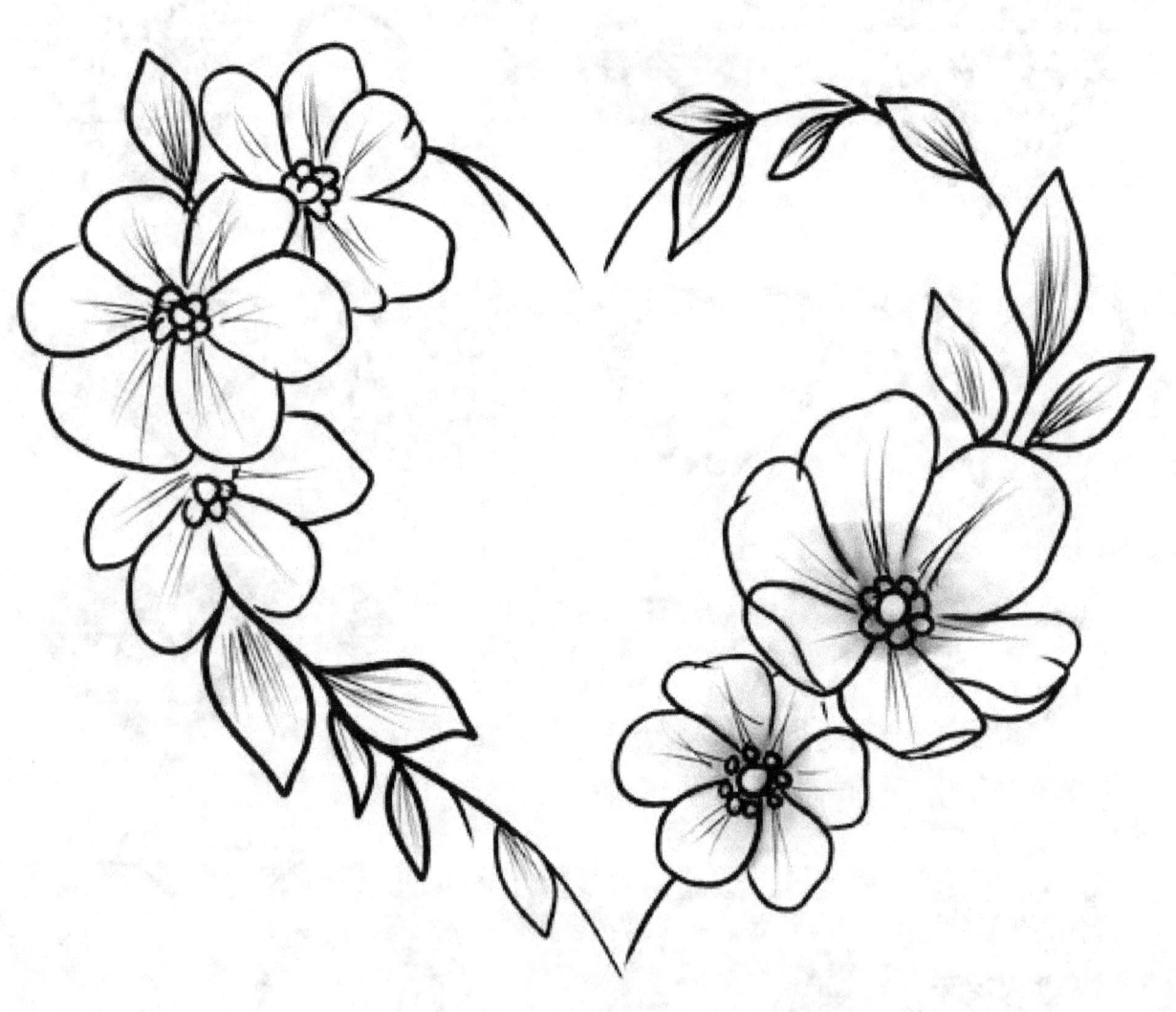

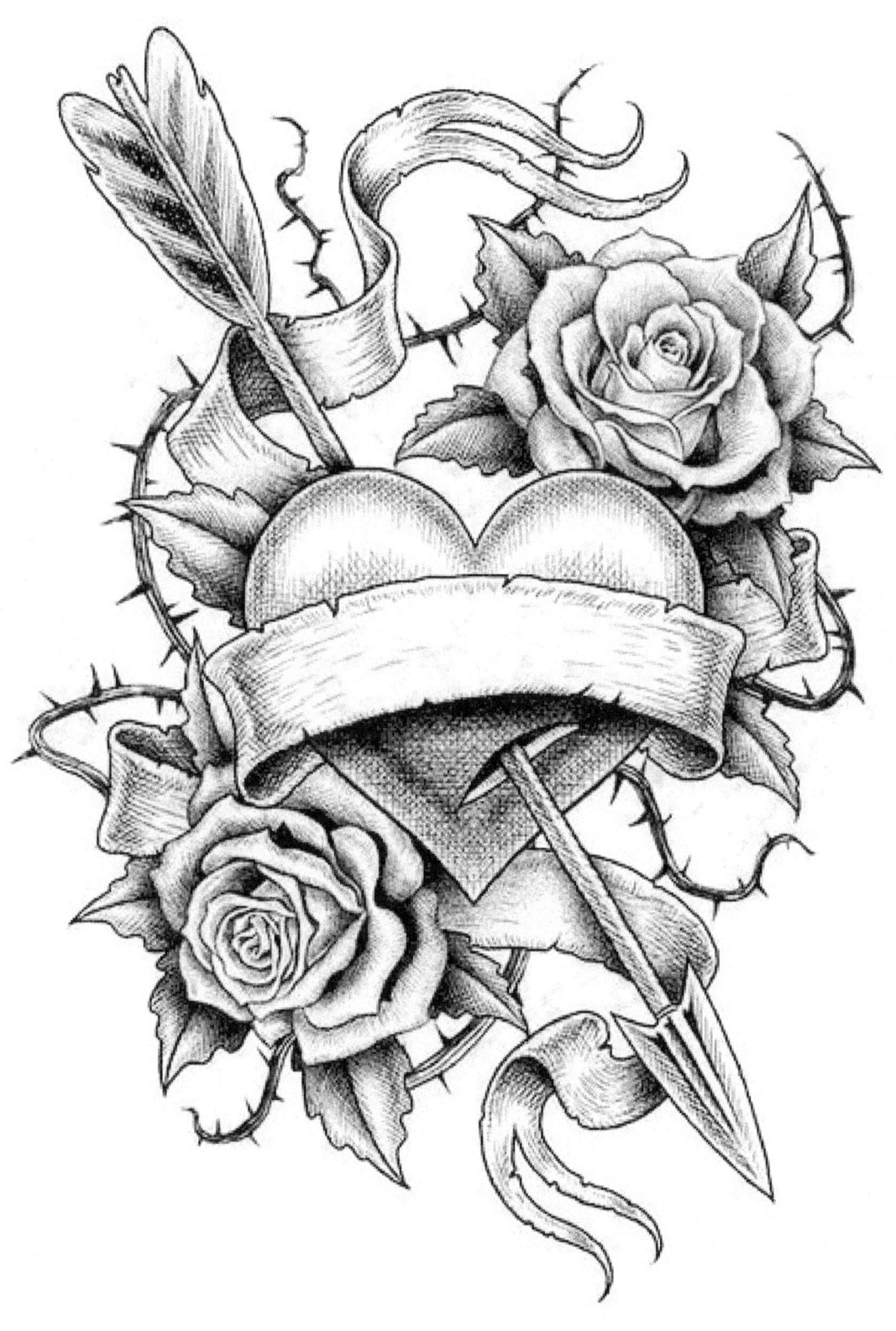

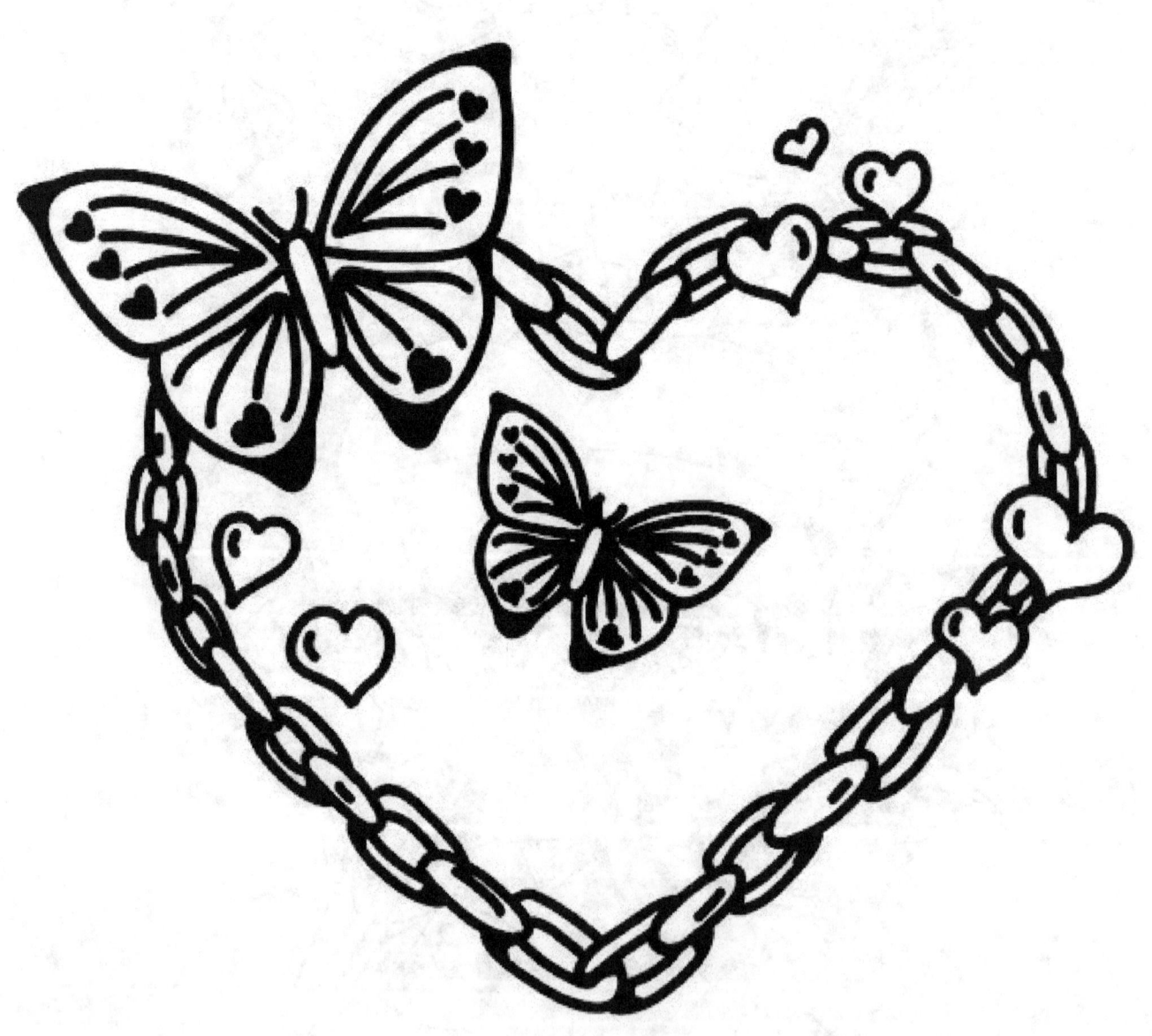

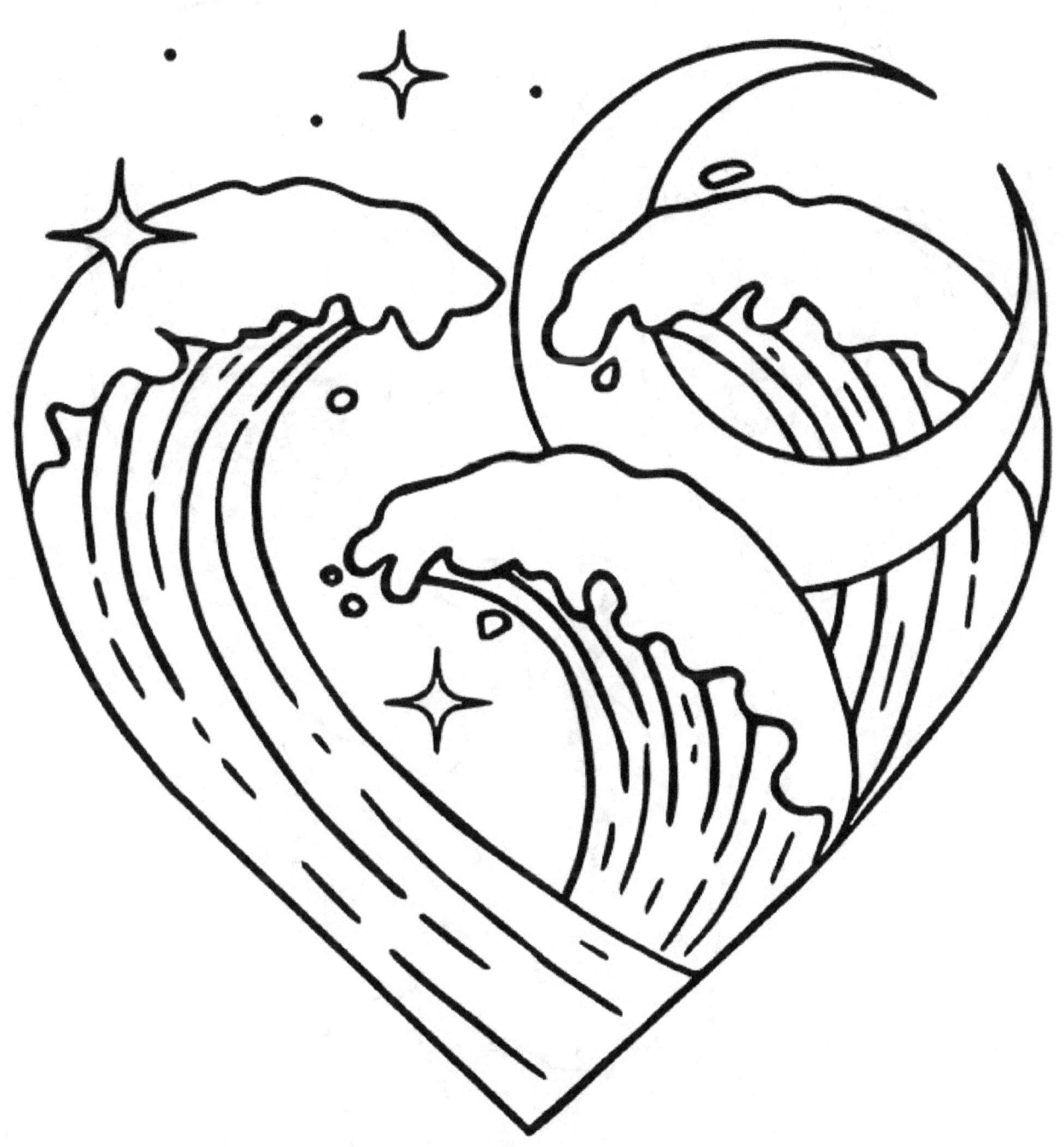

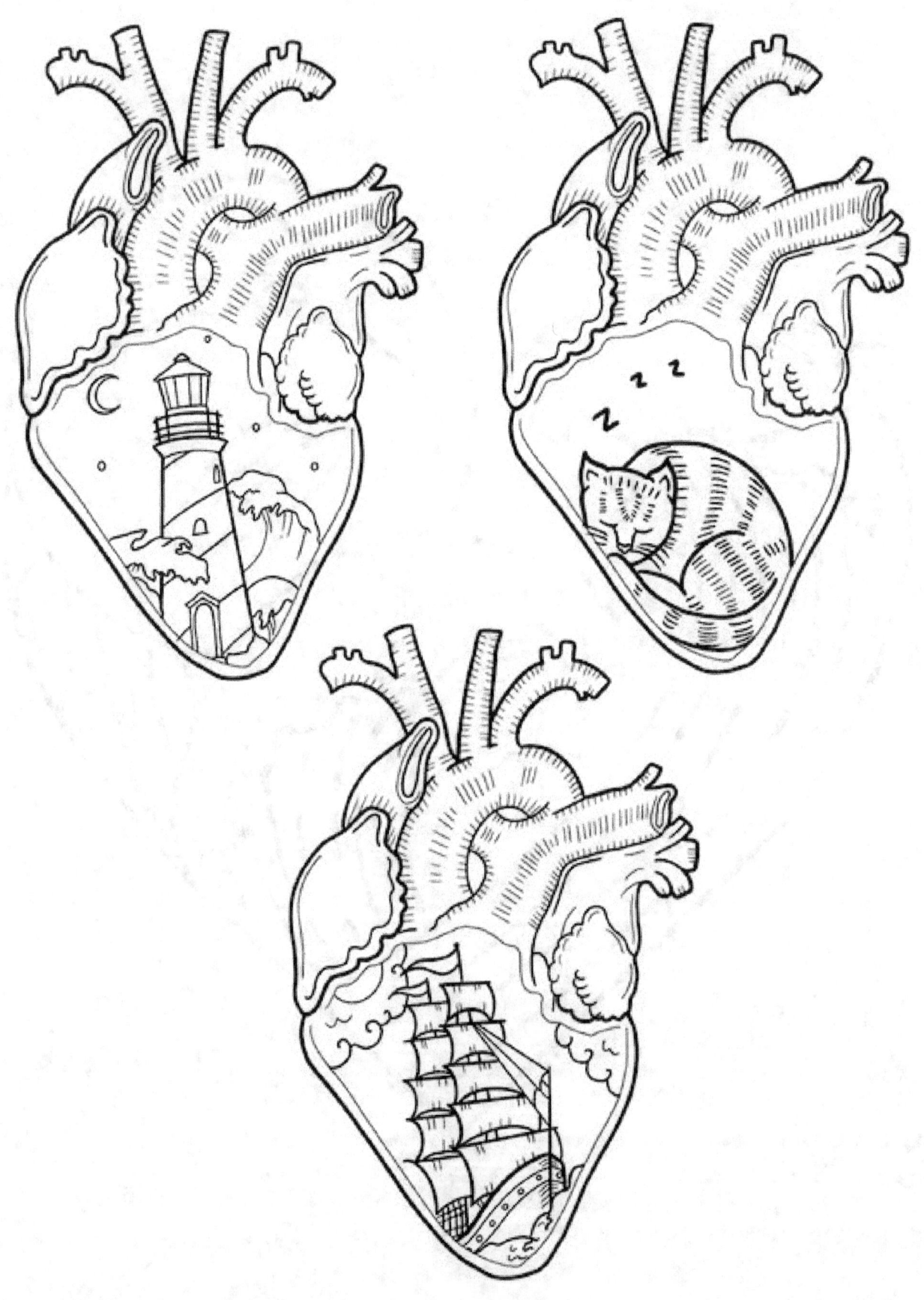

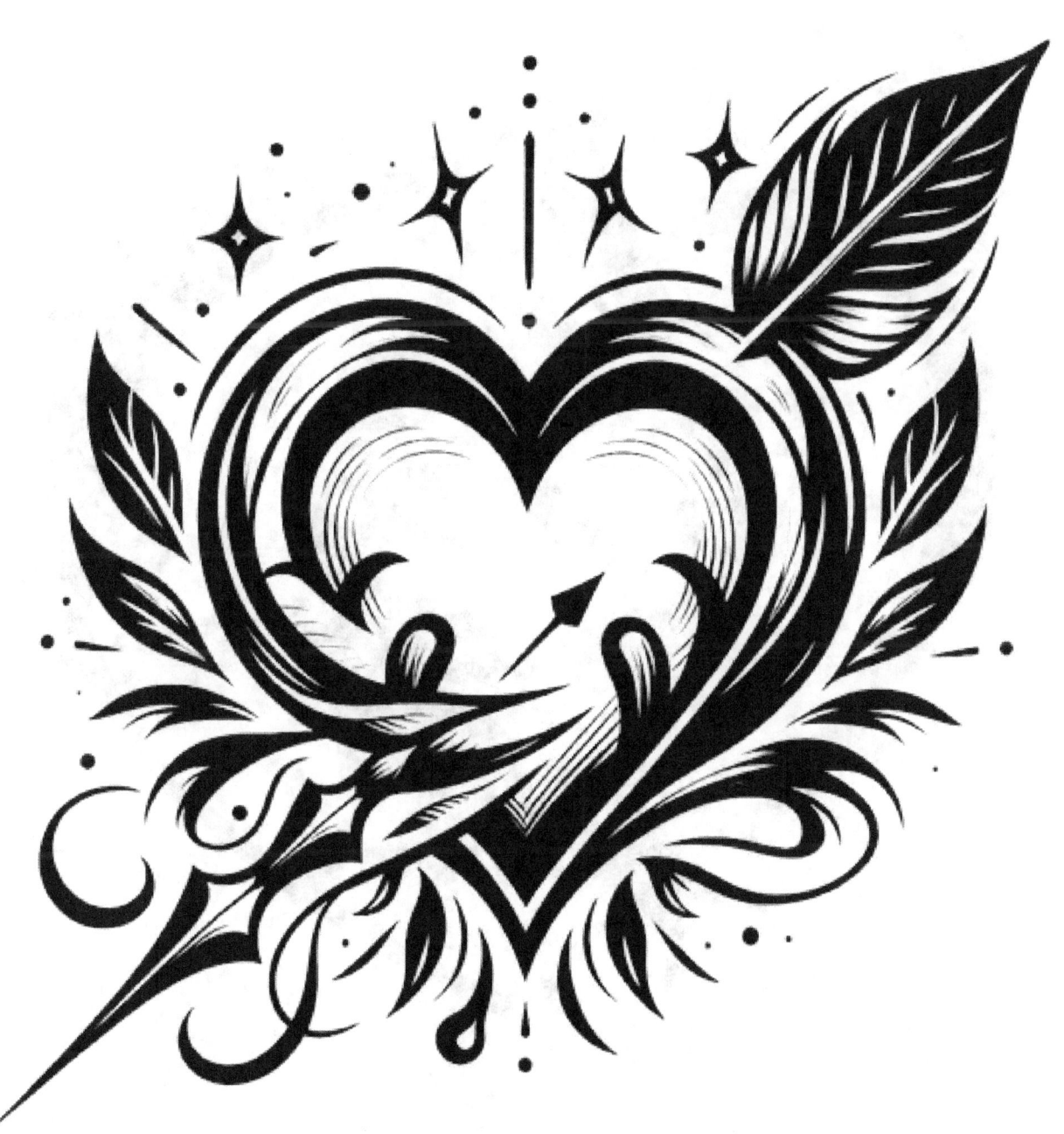

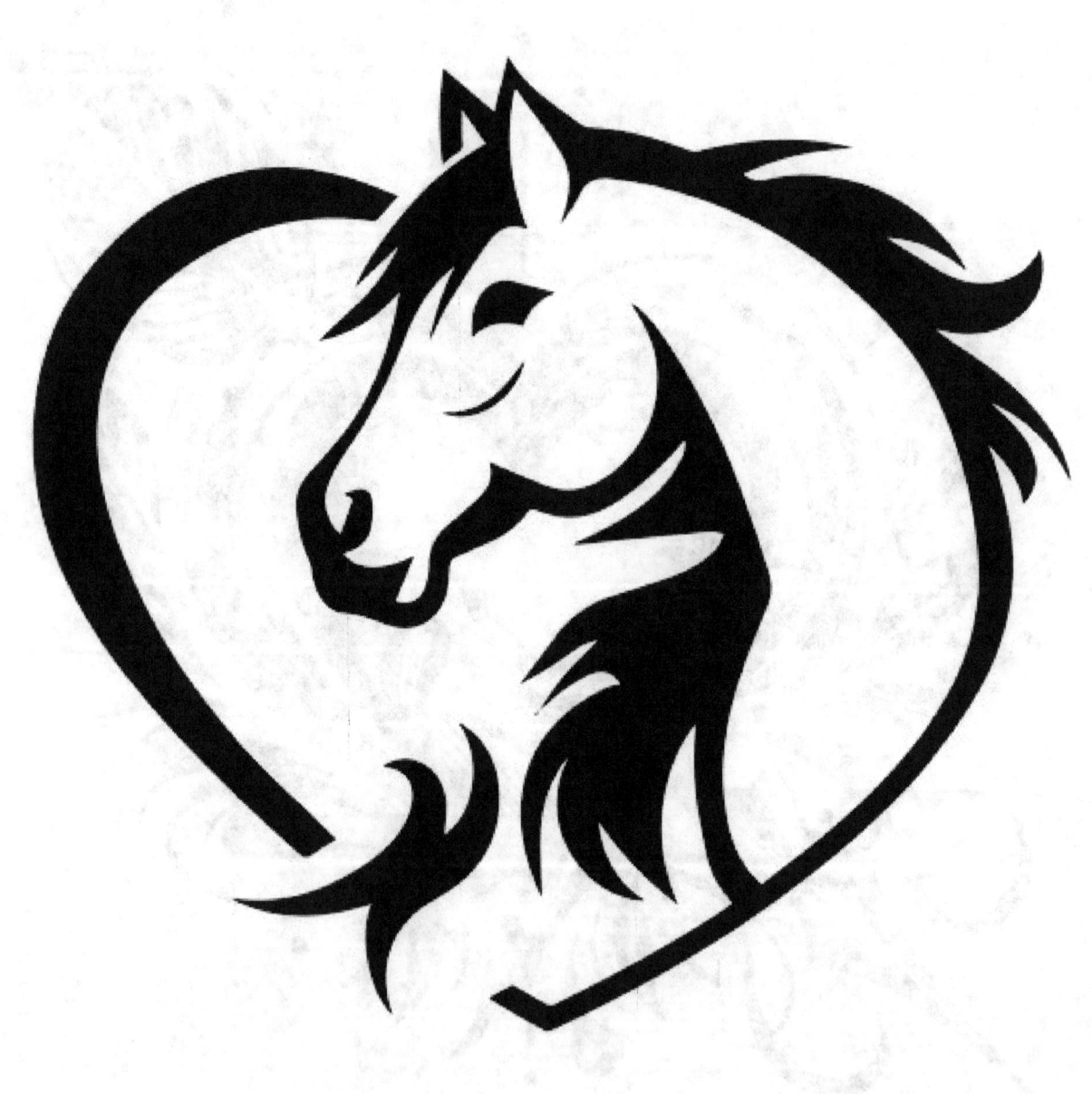

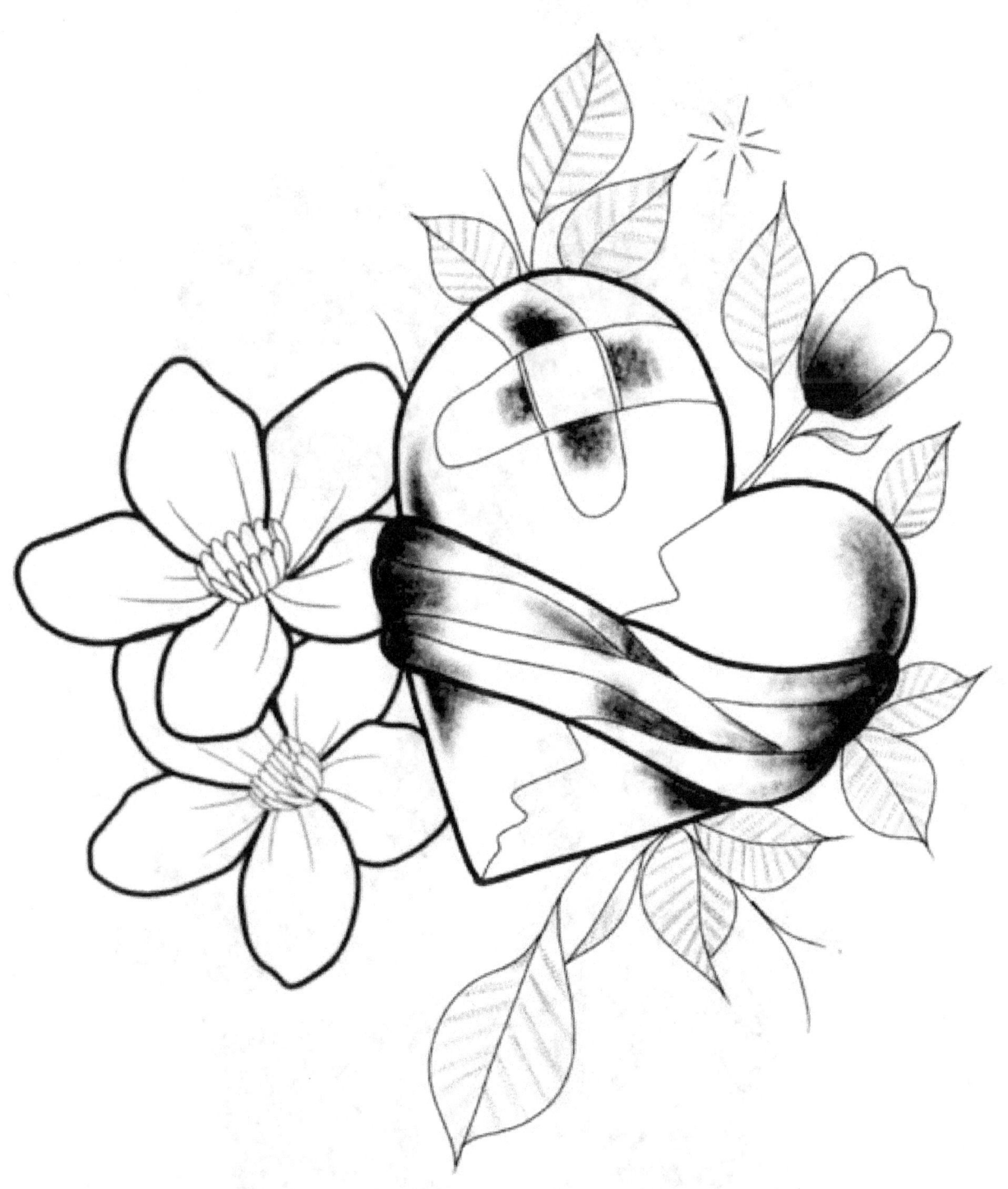

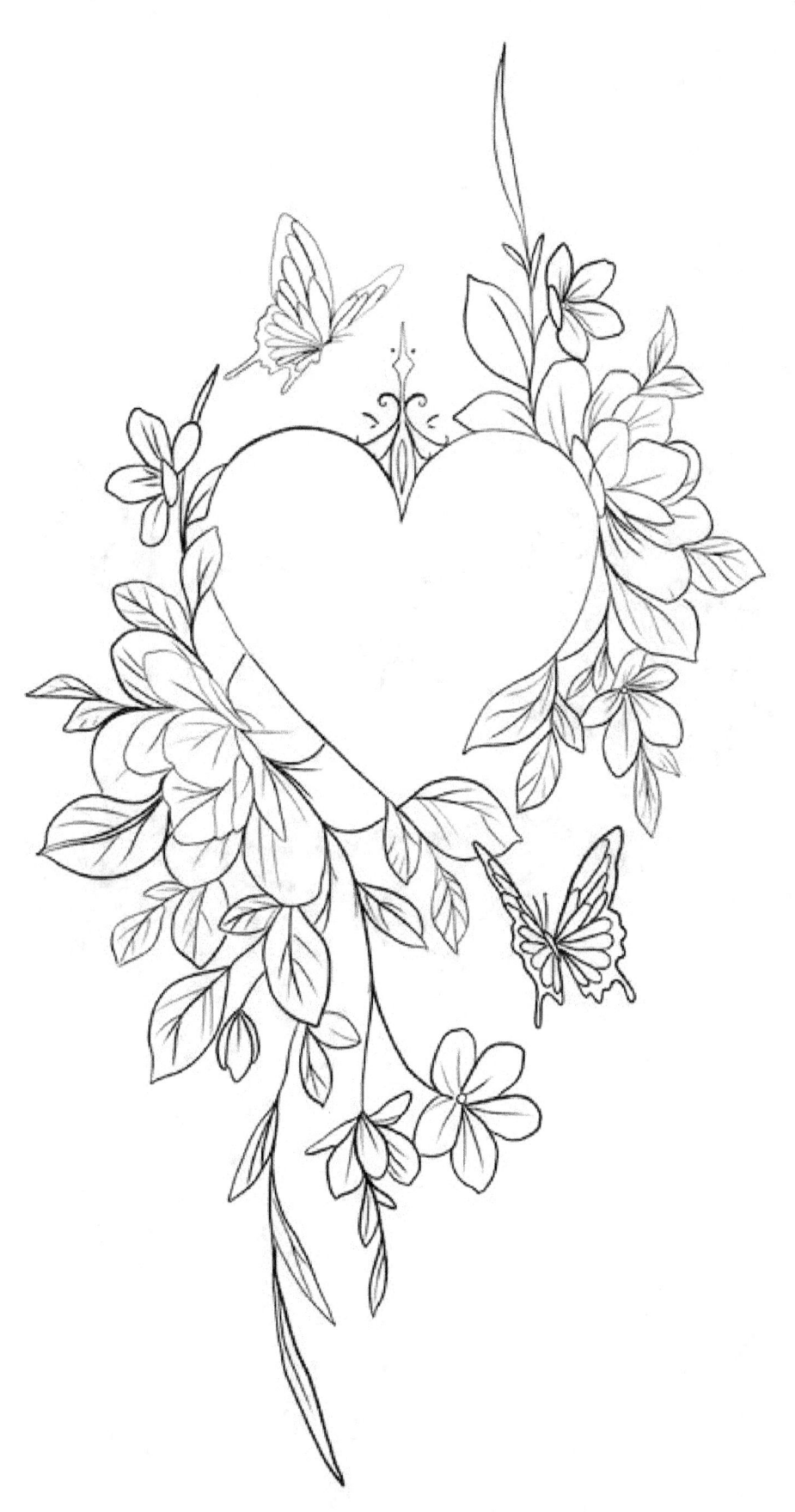

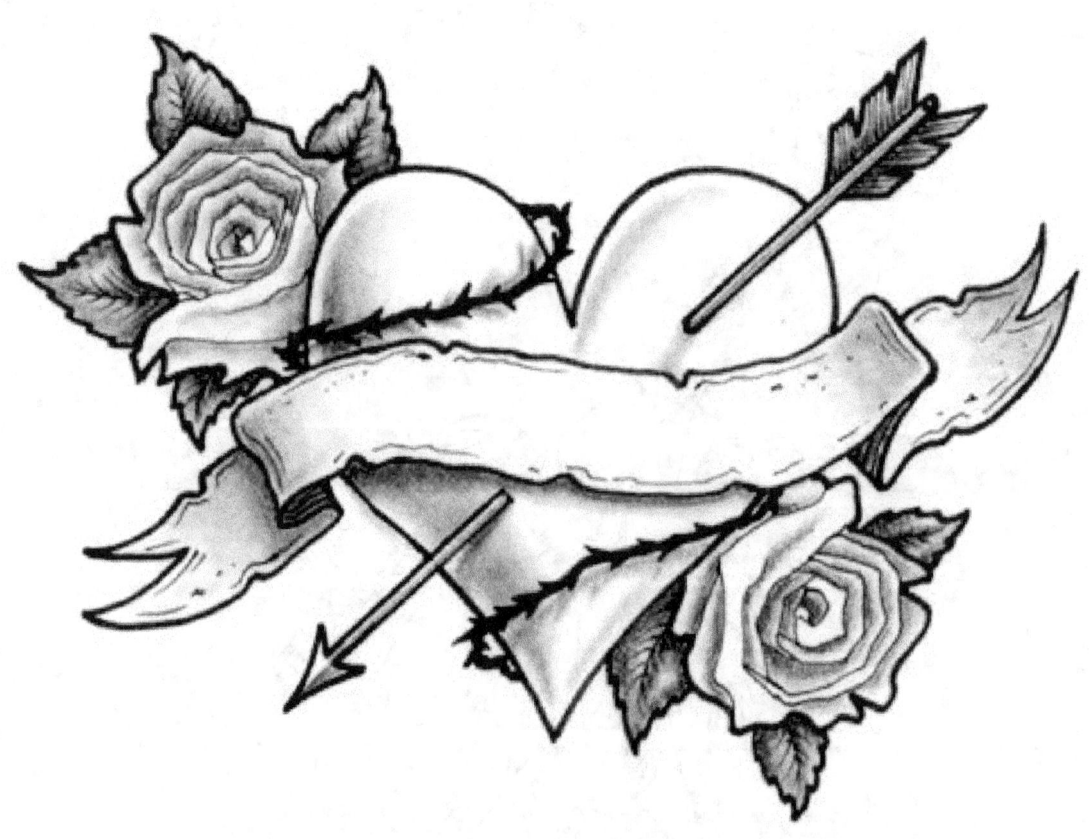

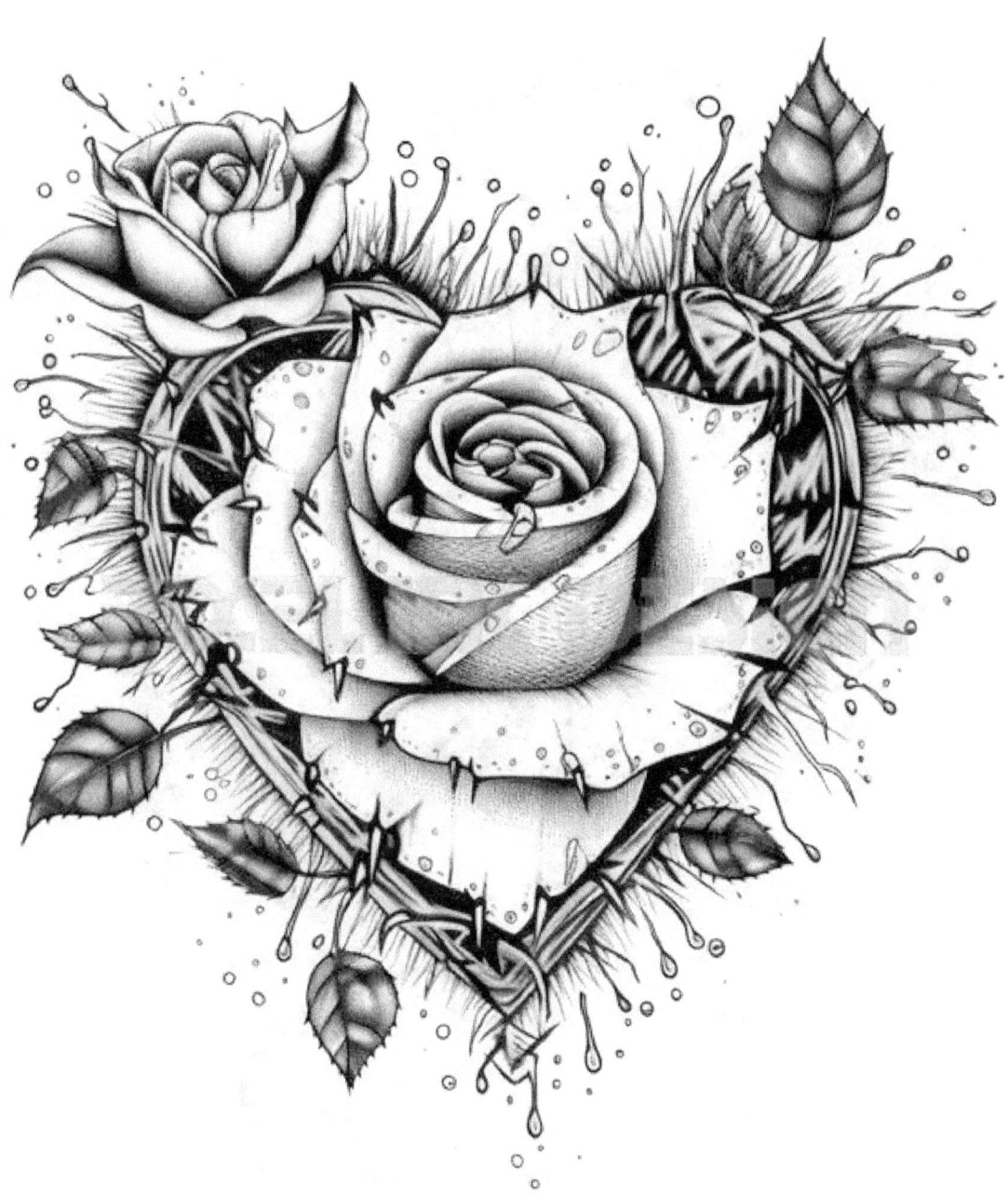

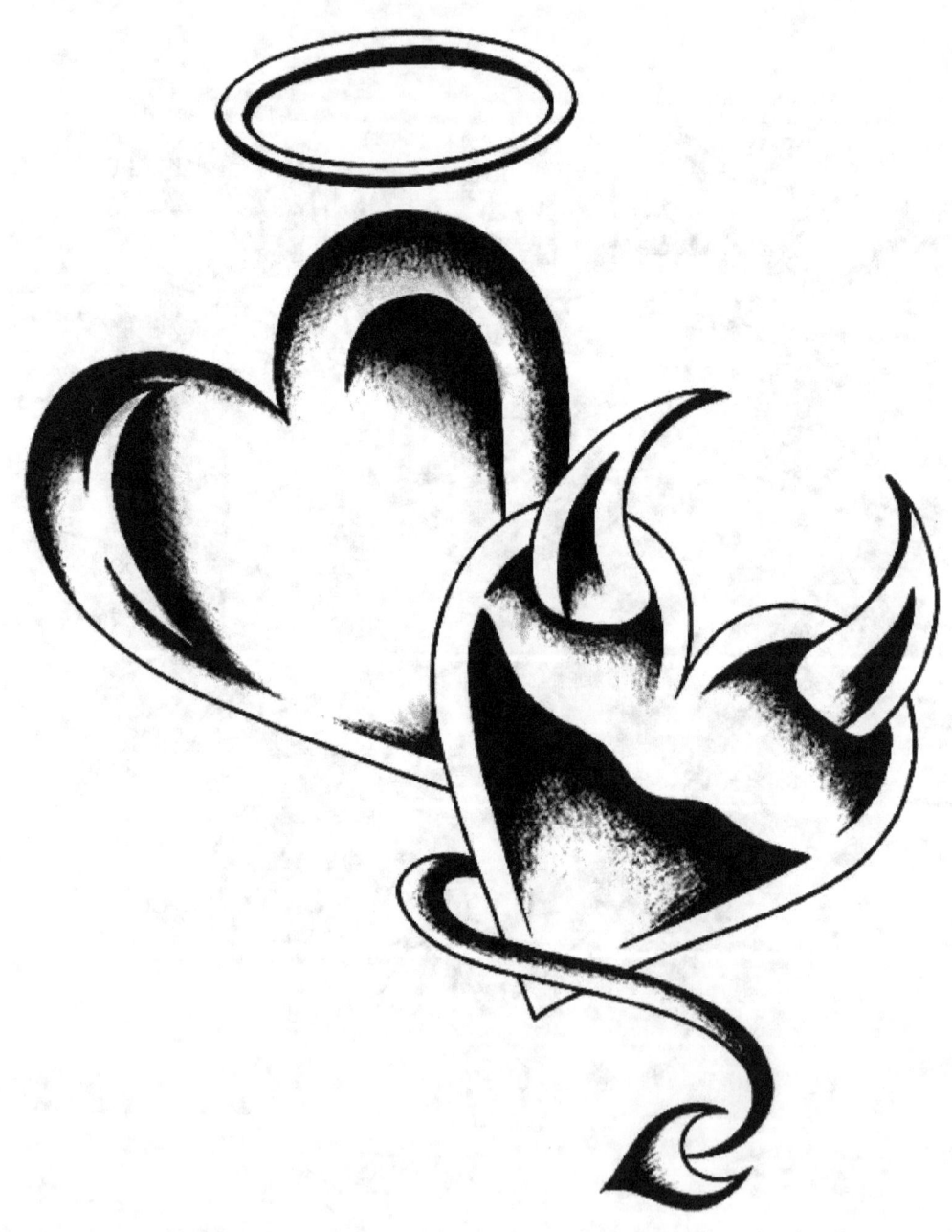

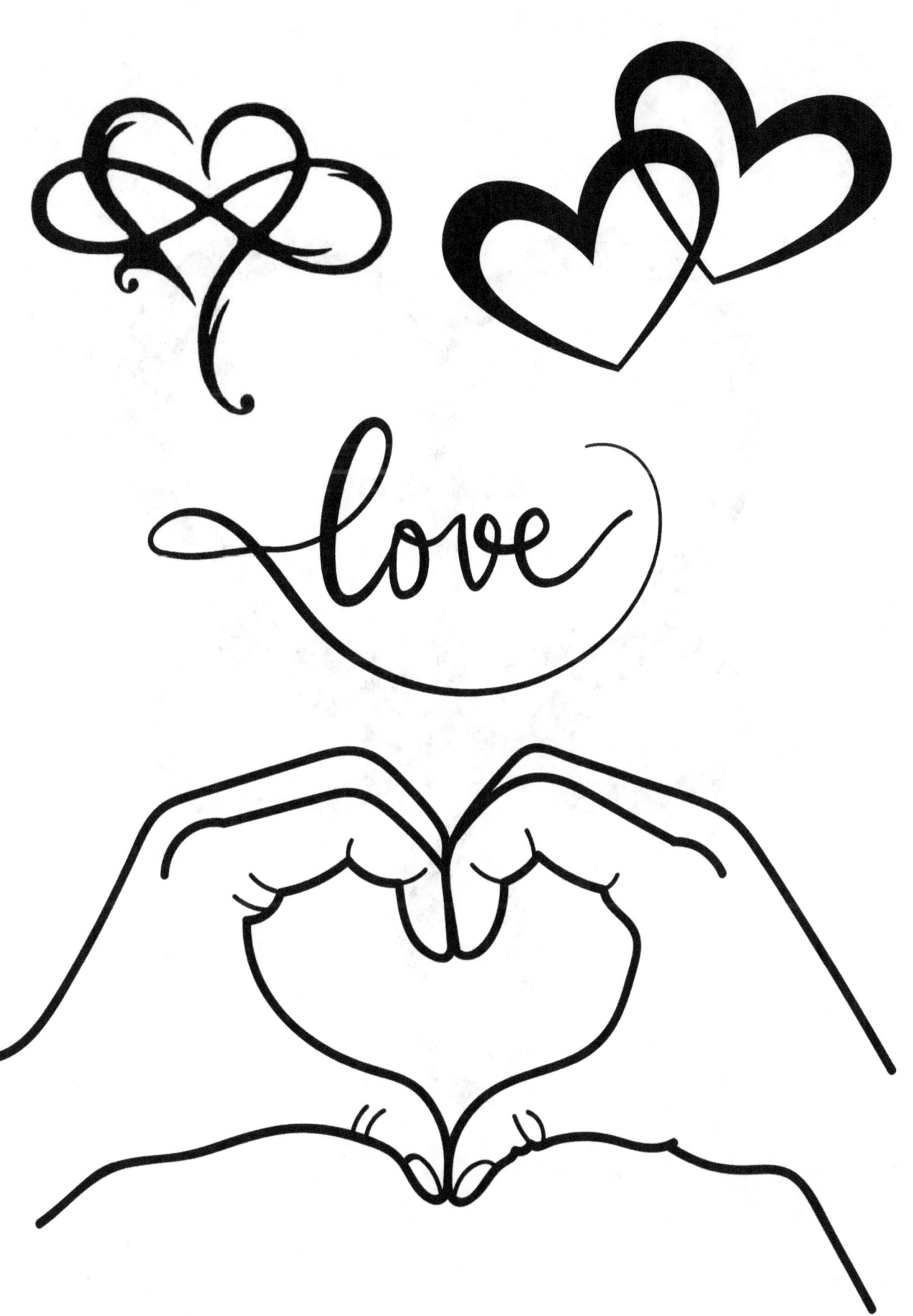

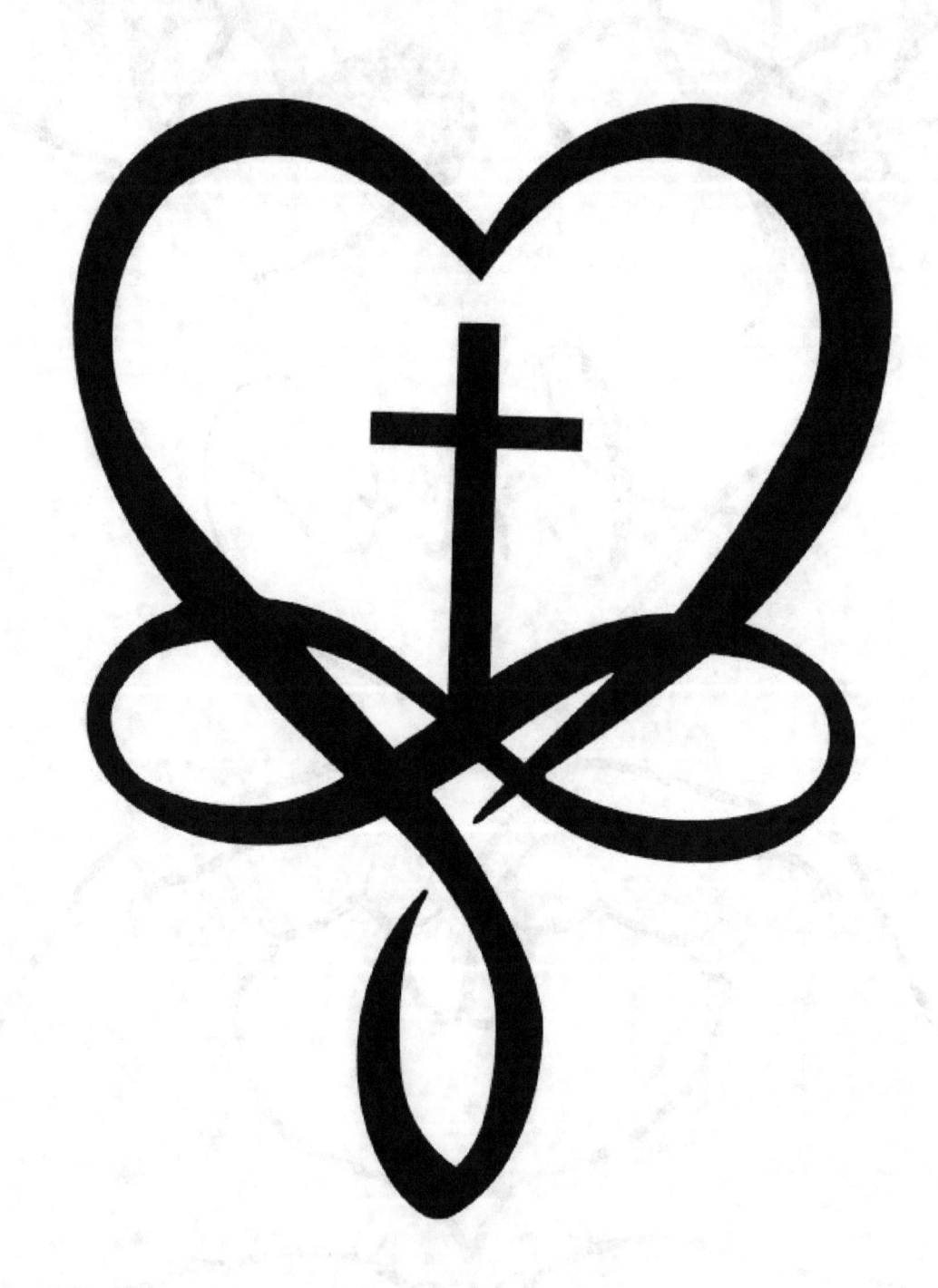

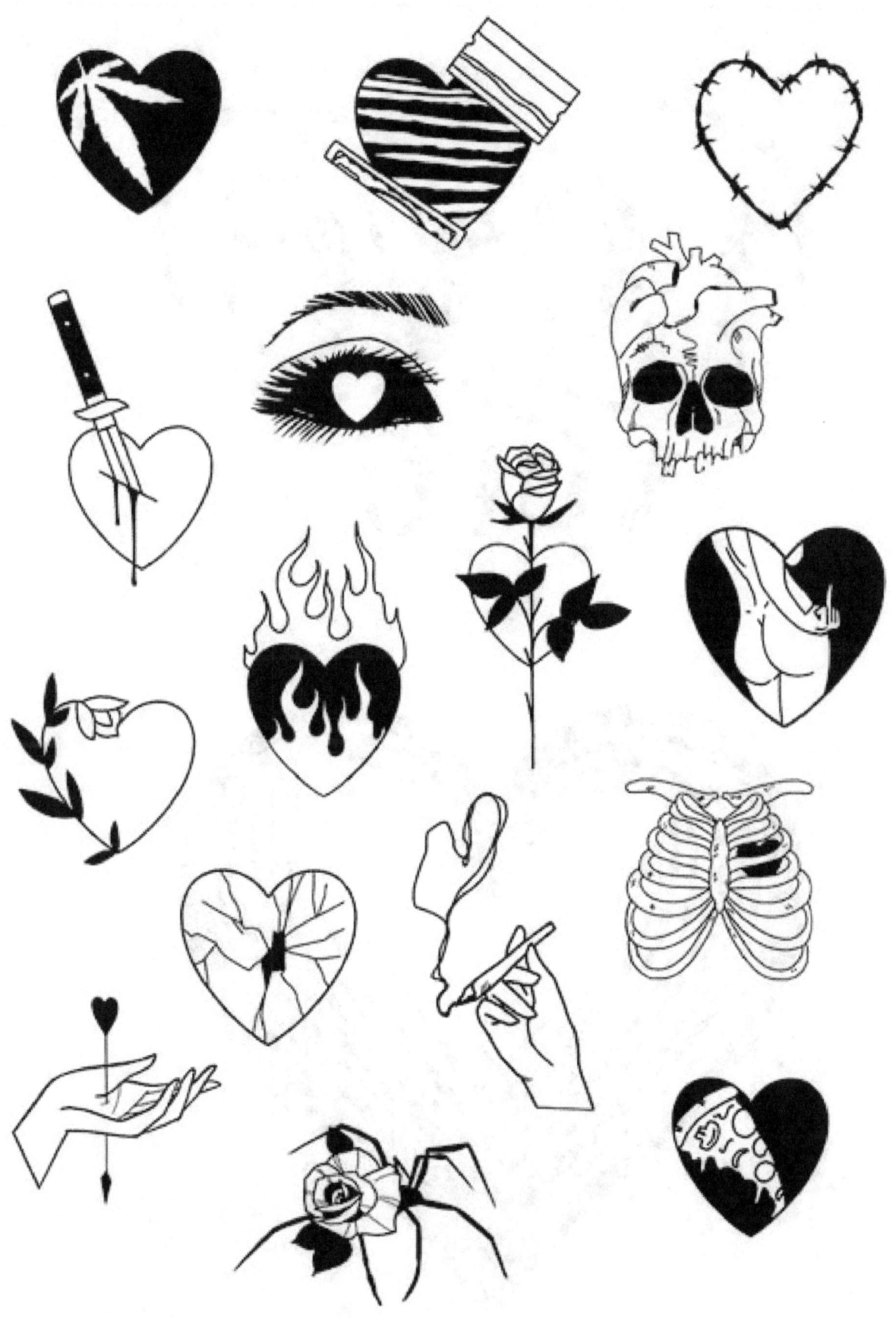

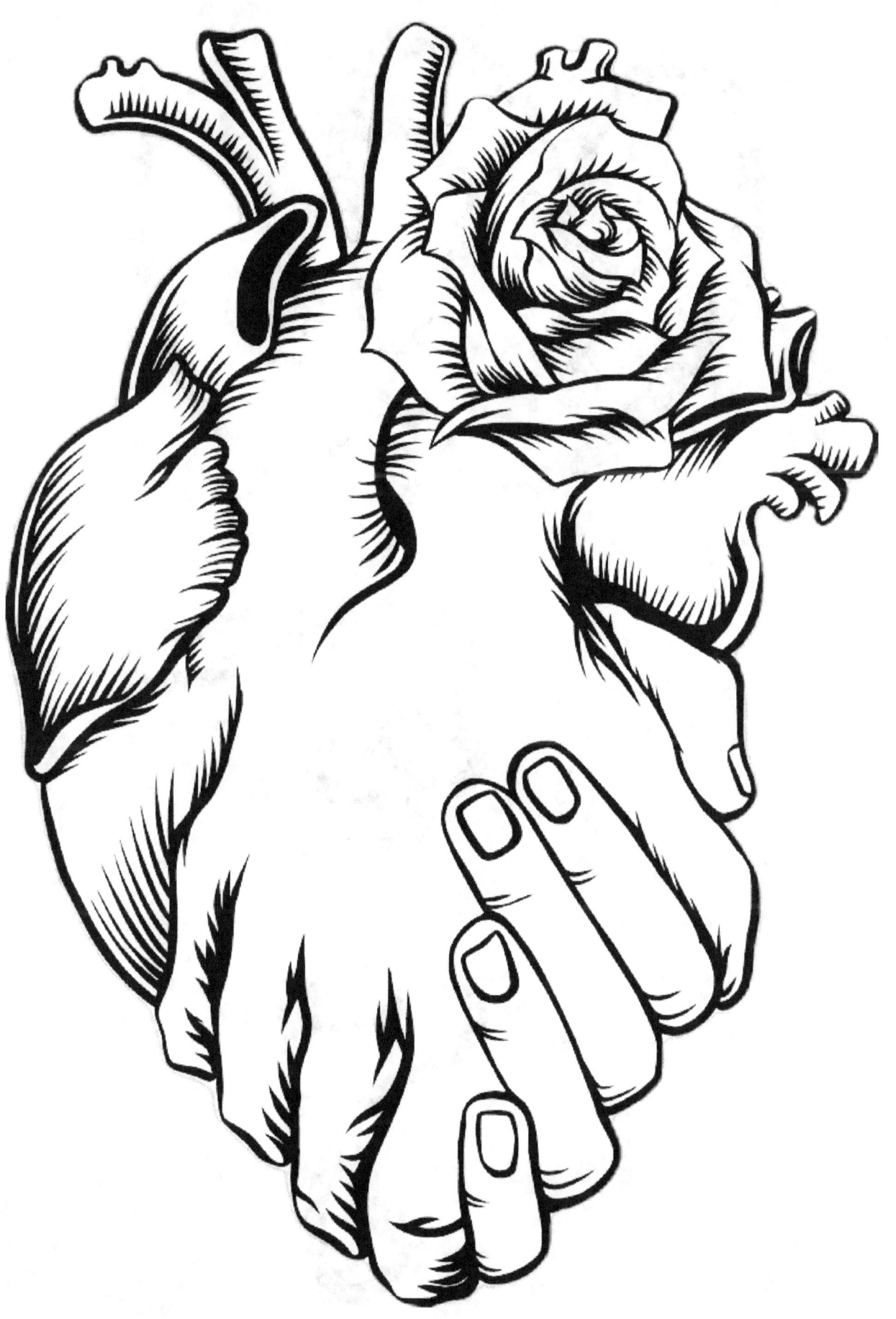

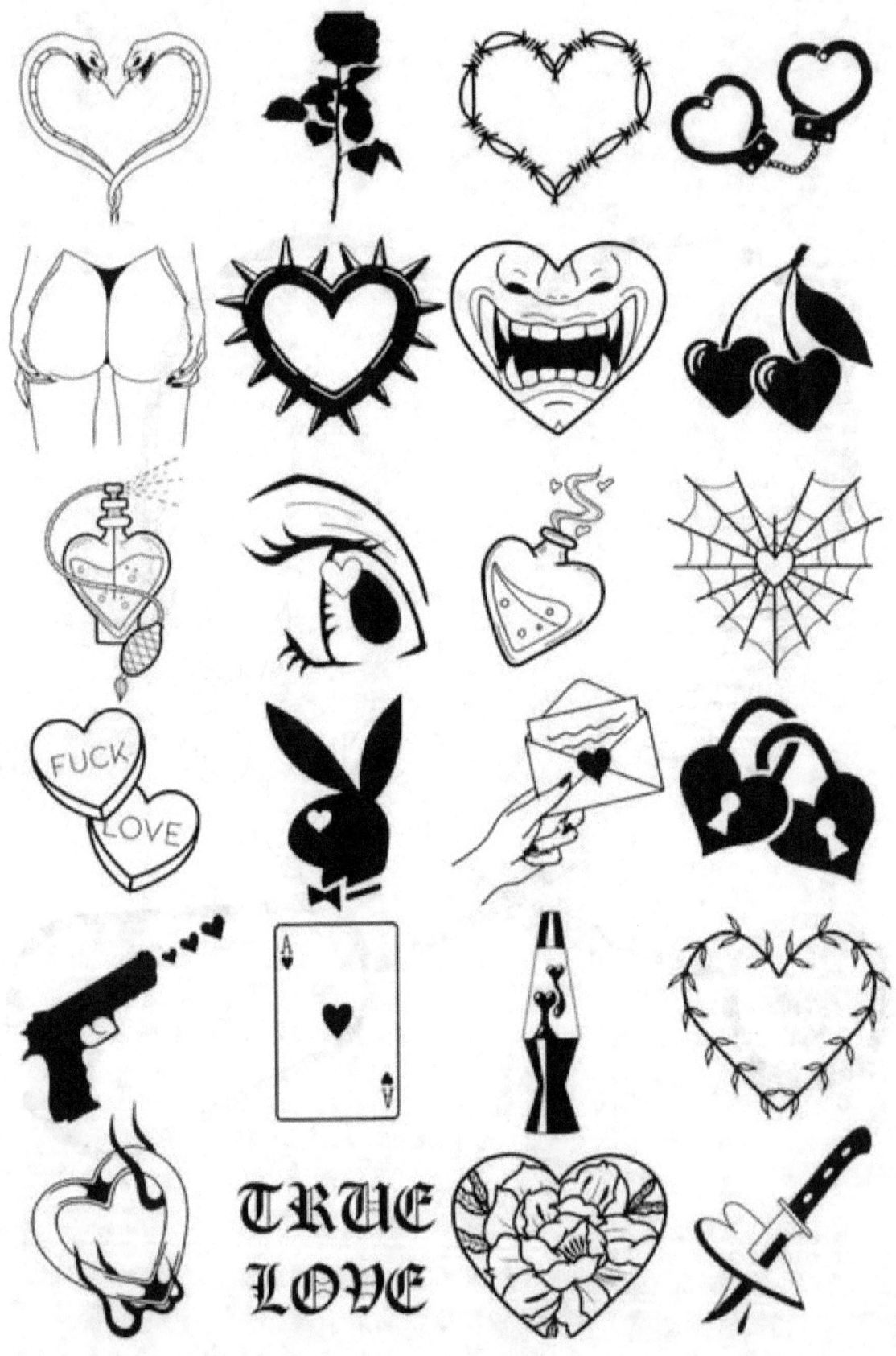

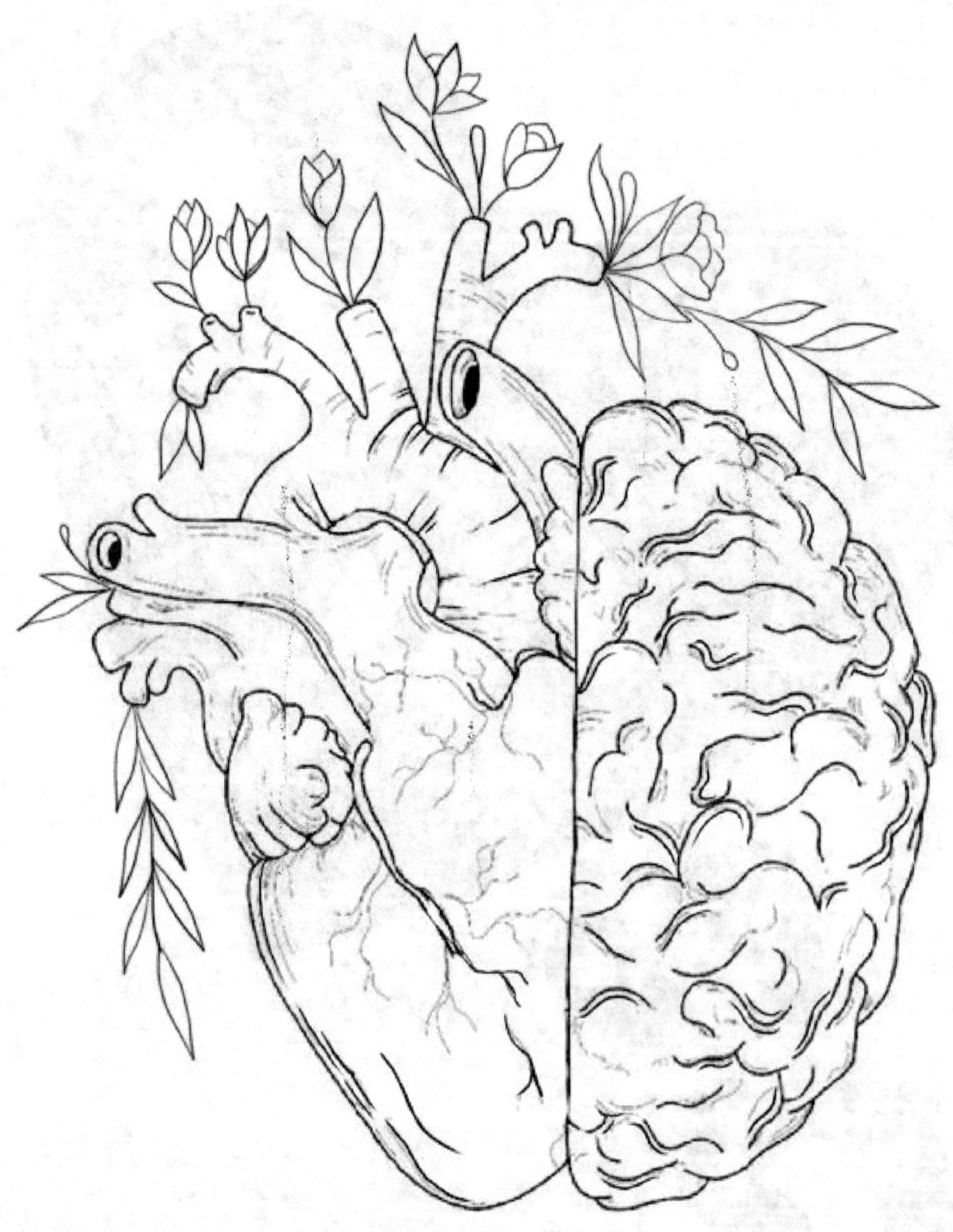

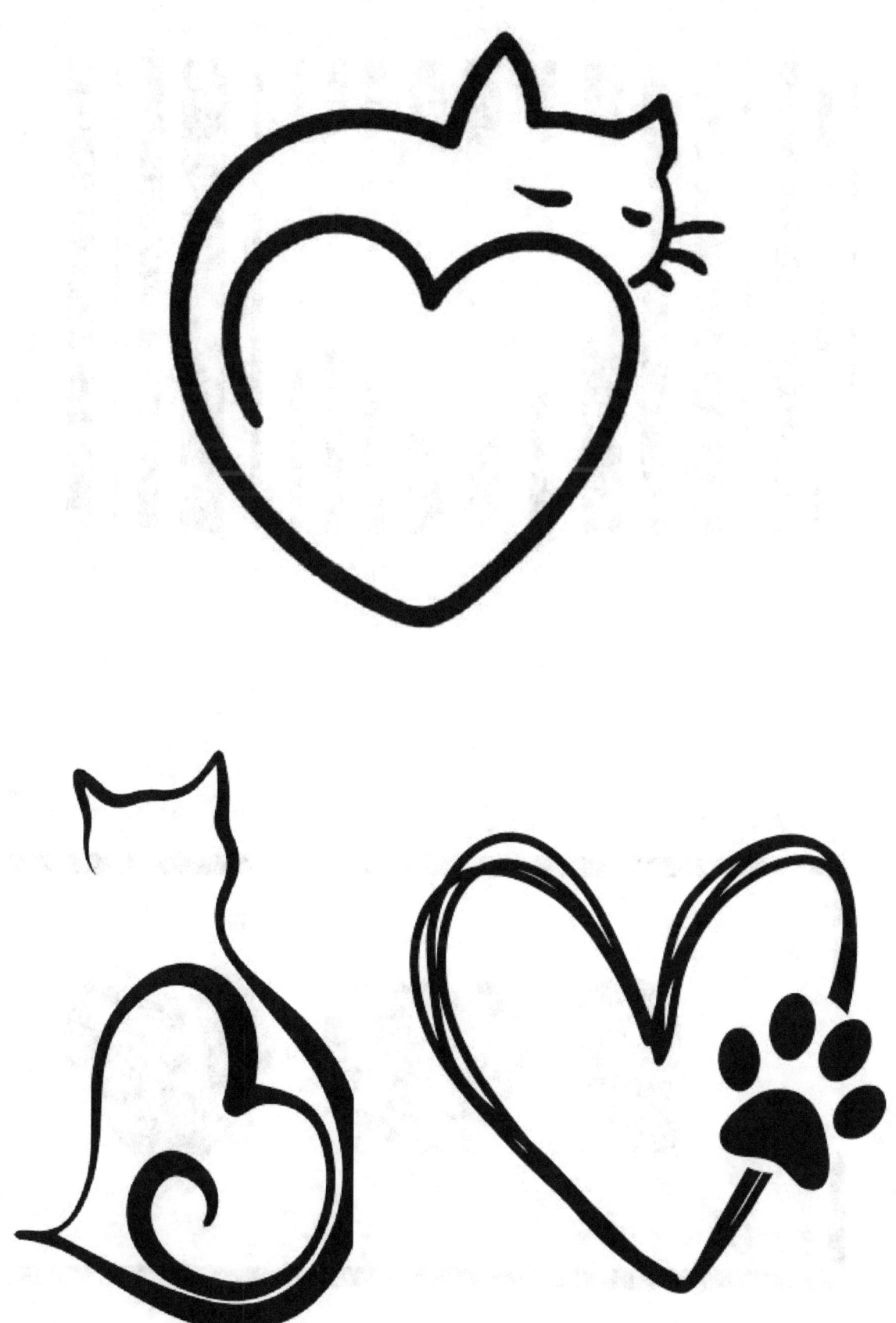

journey of growth

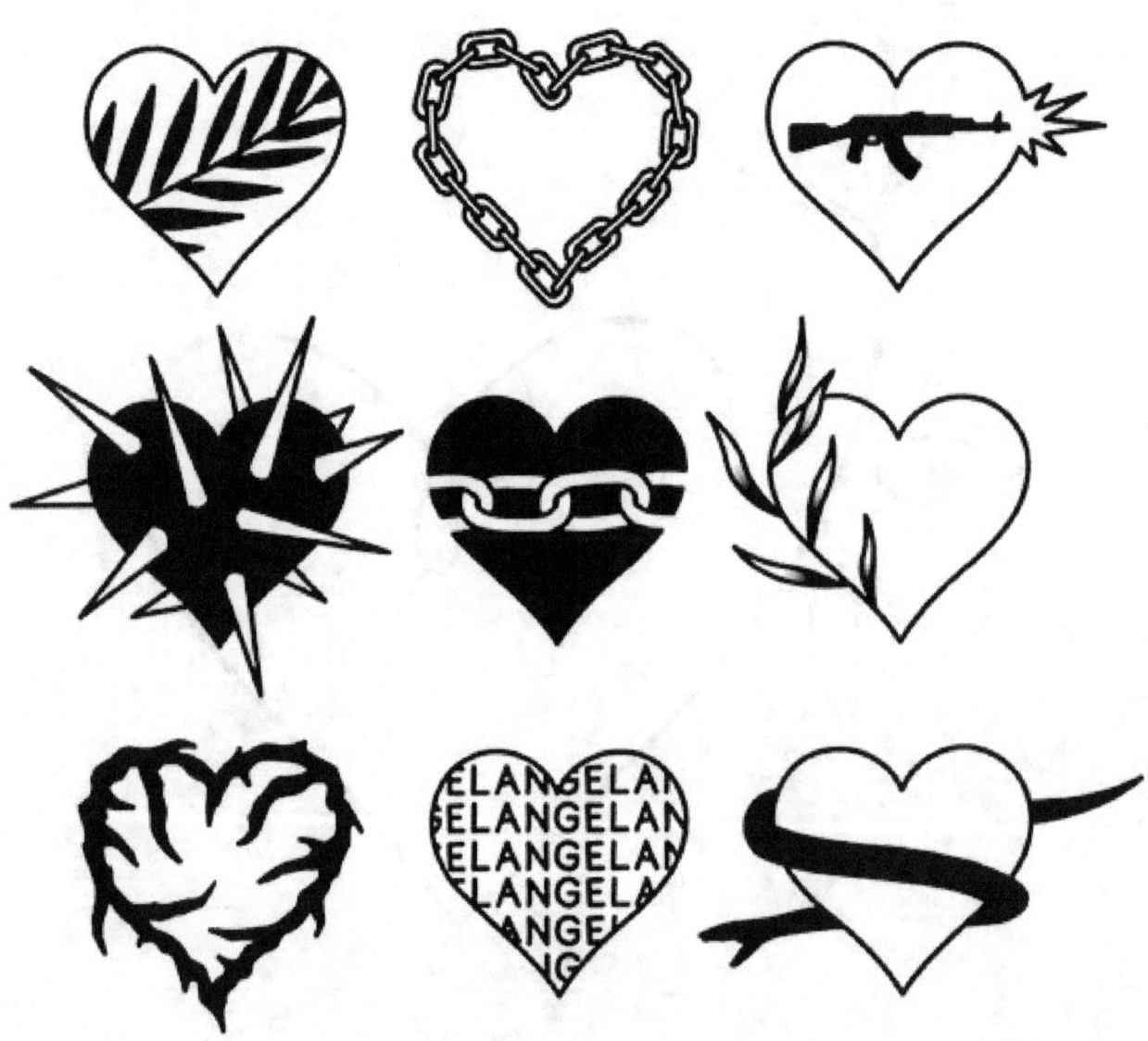

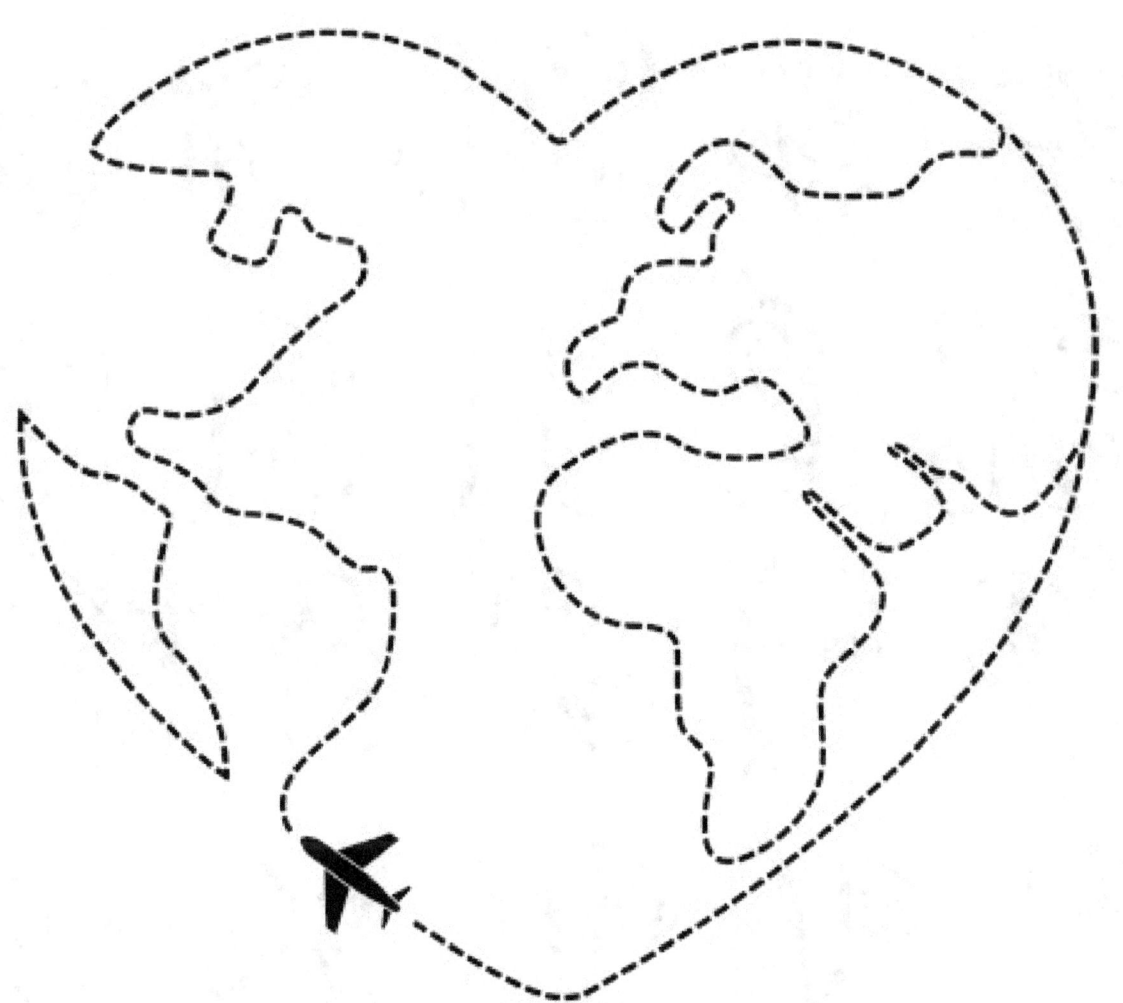

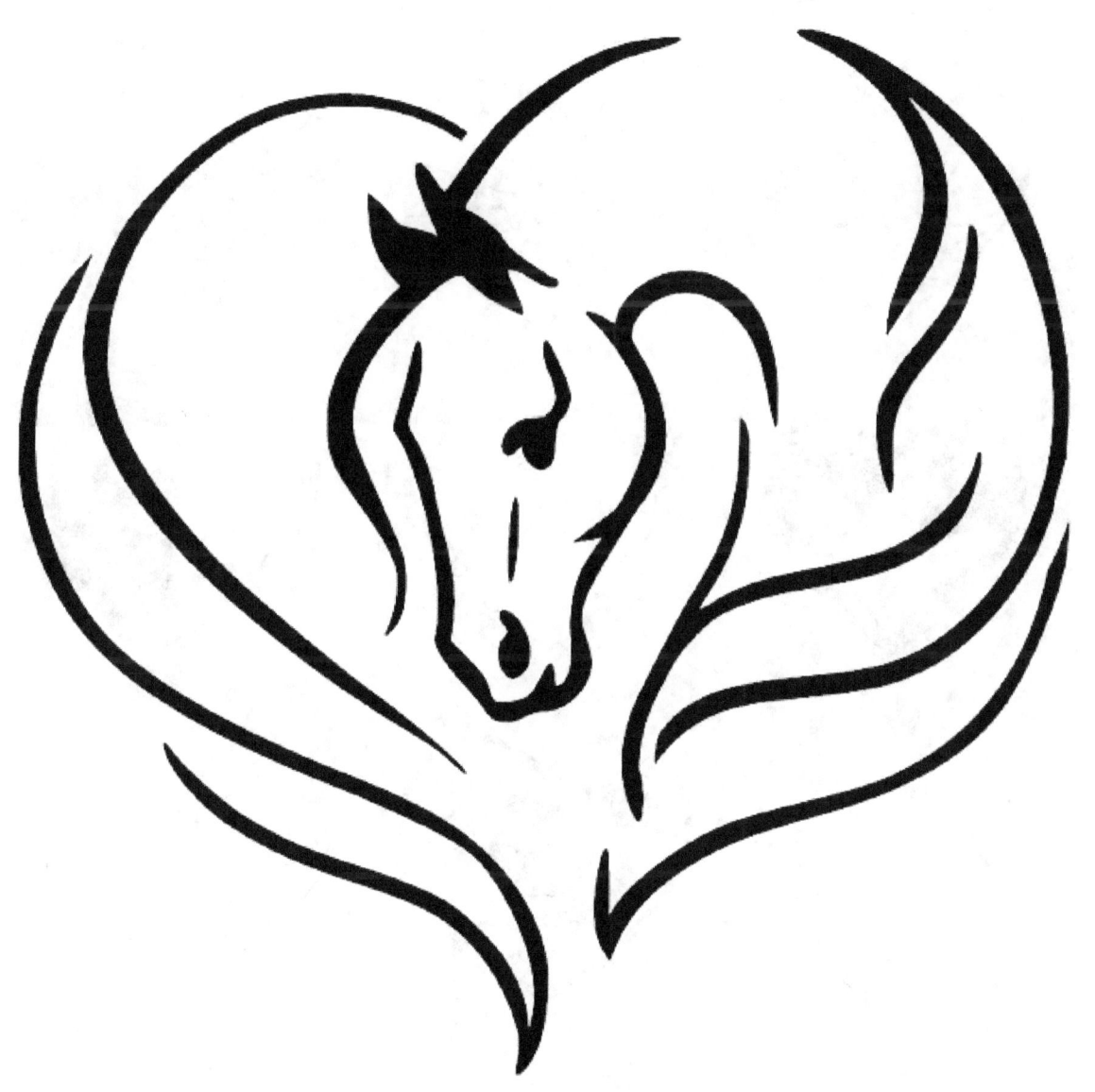

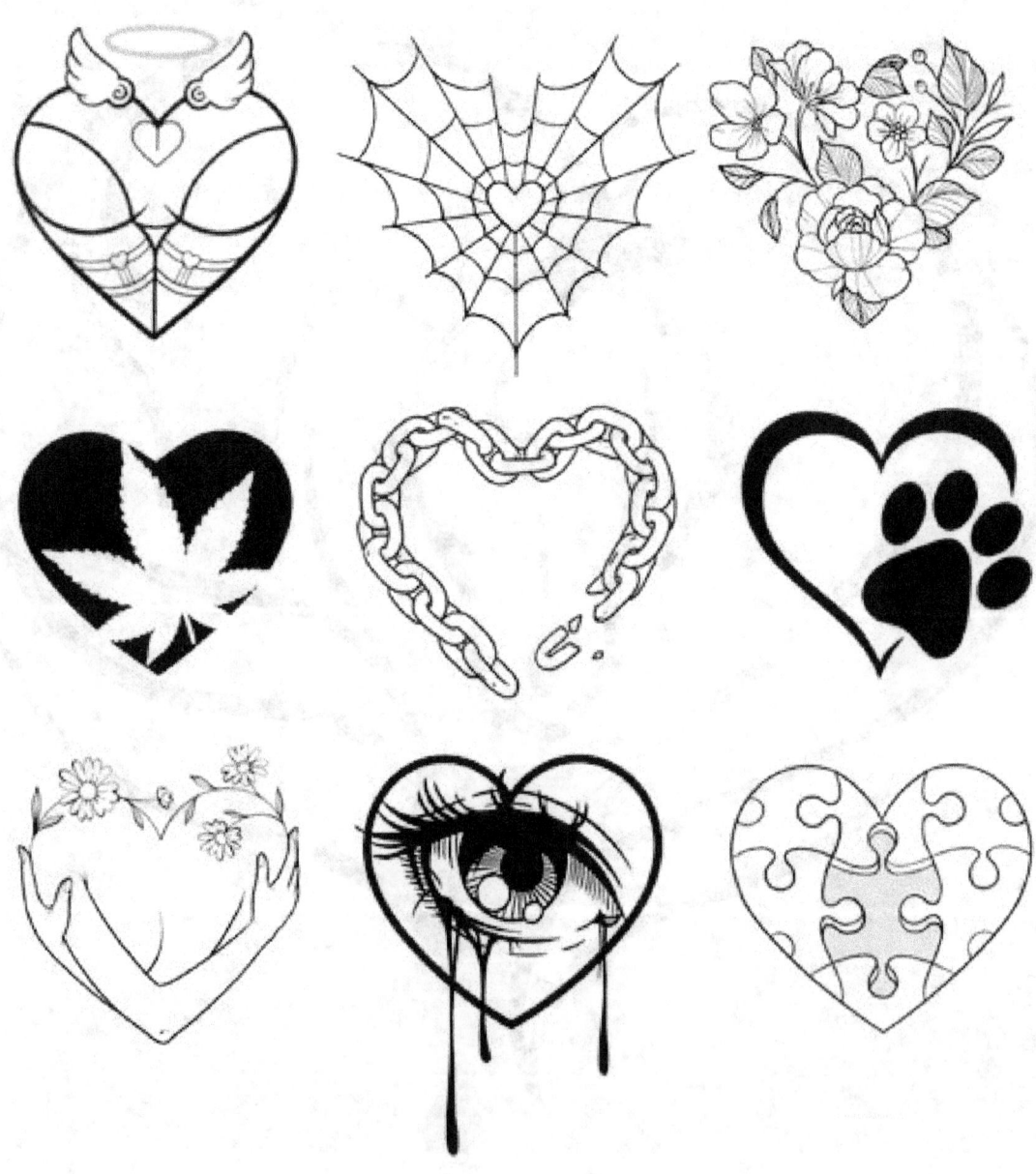

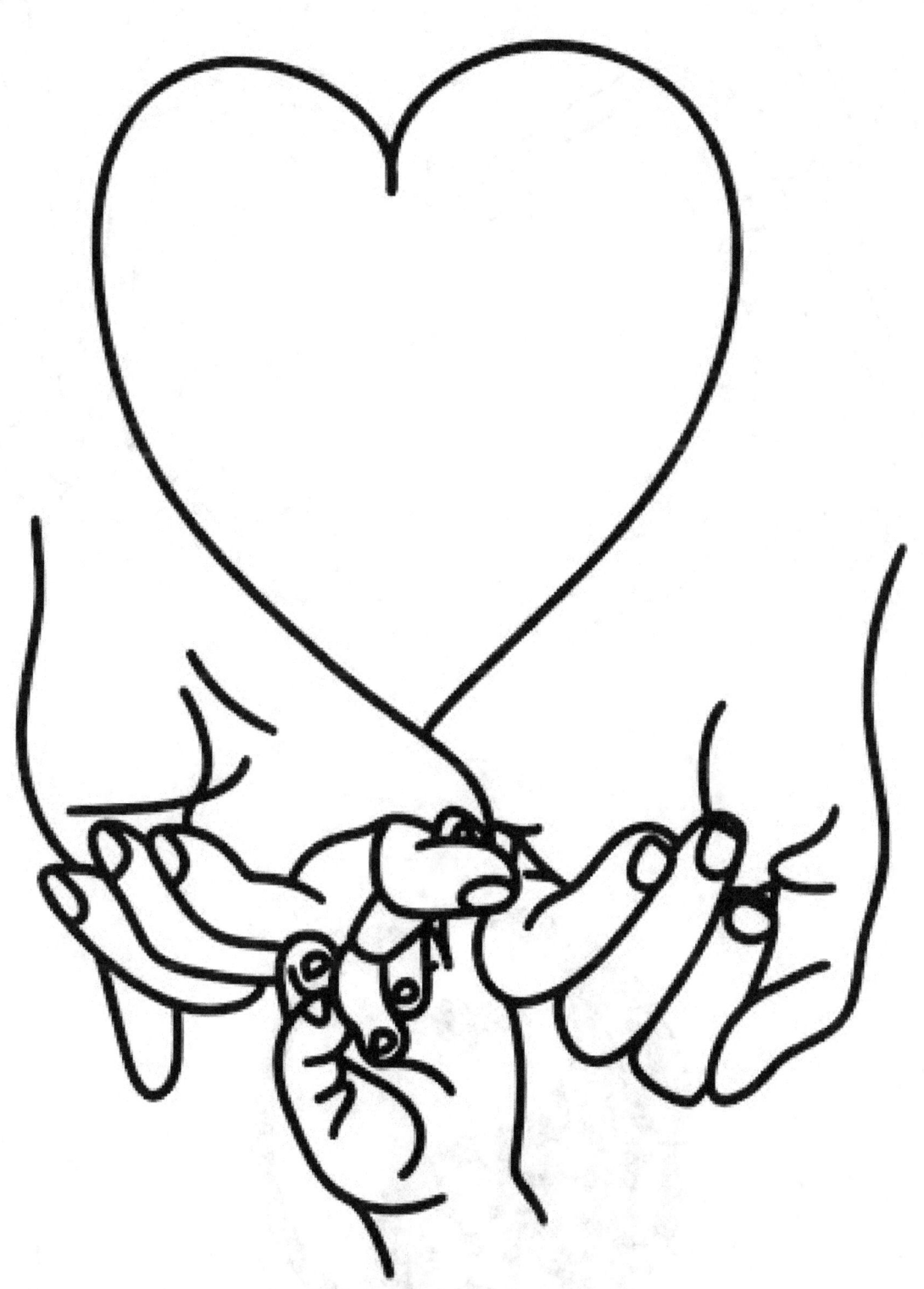

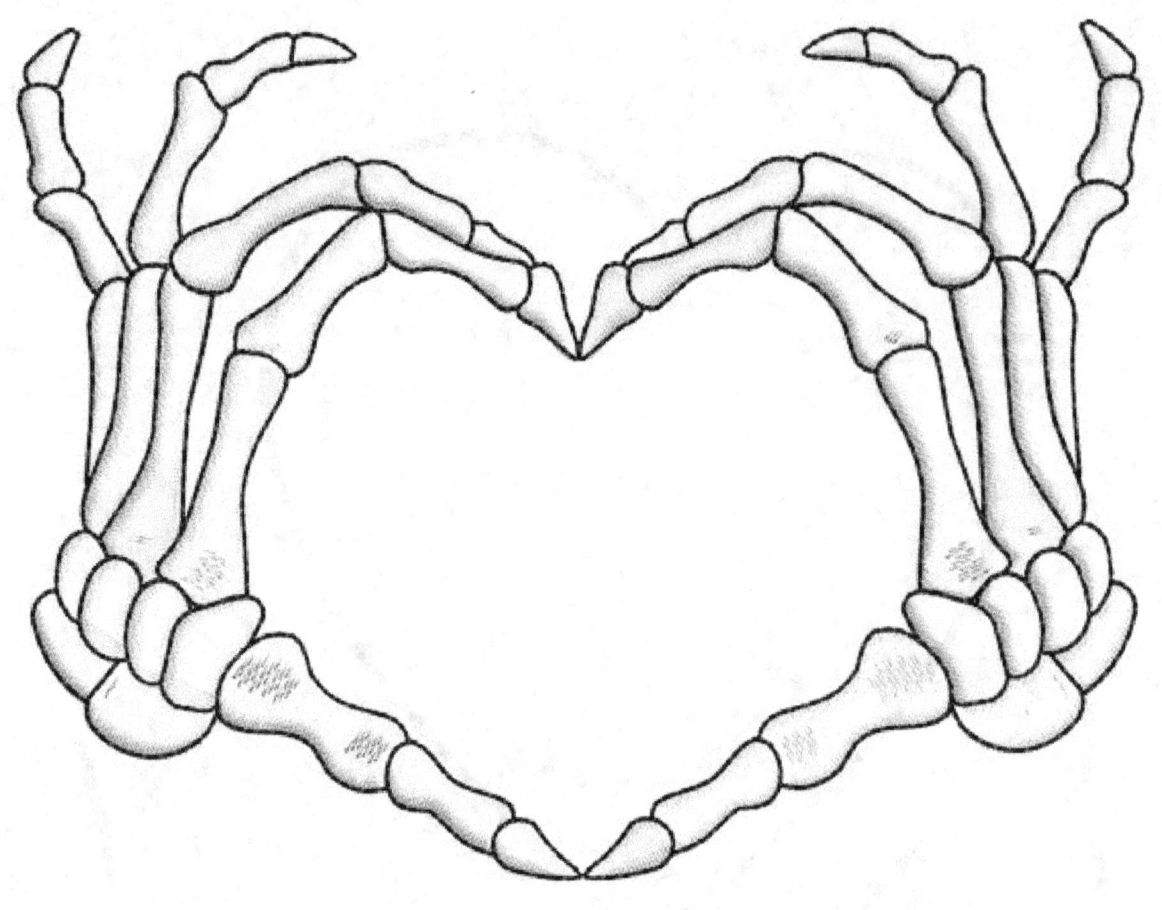

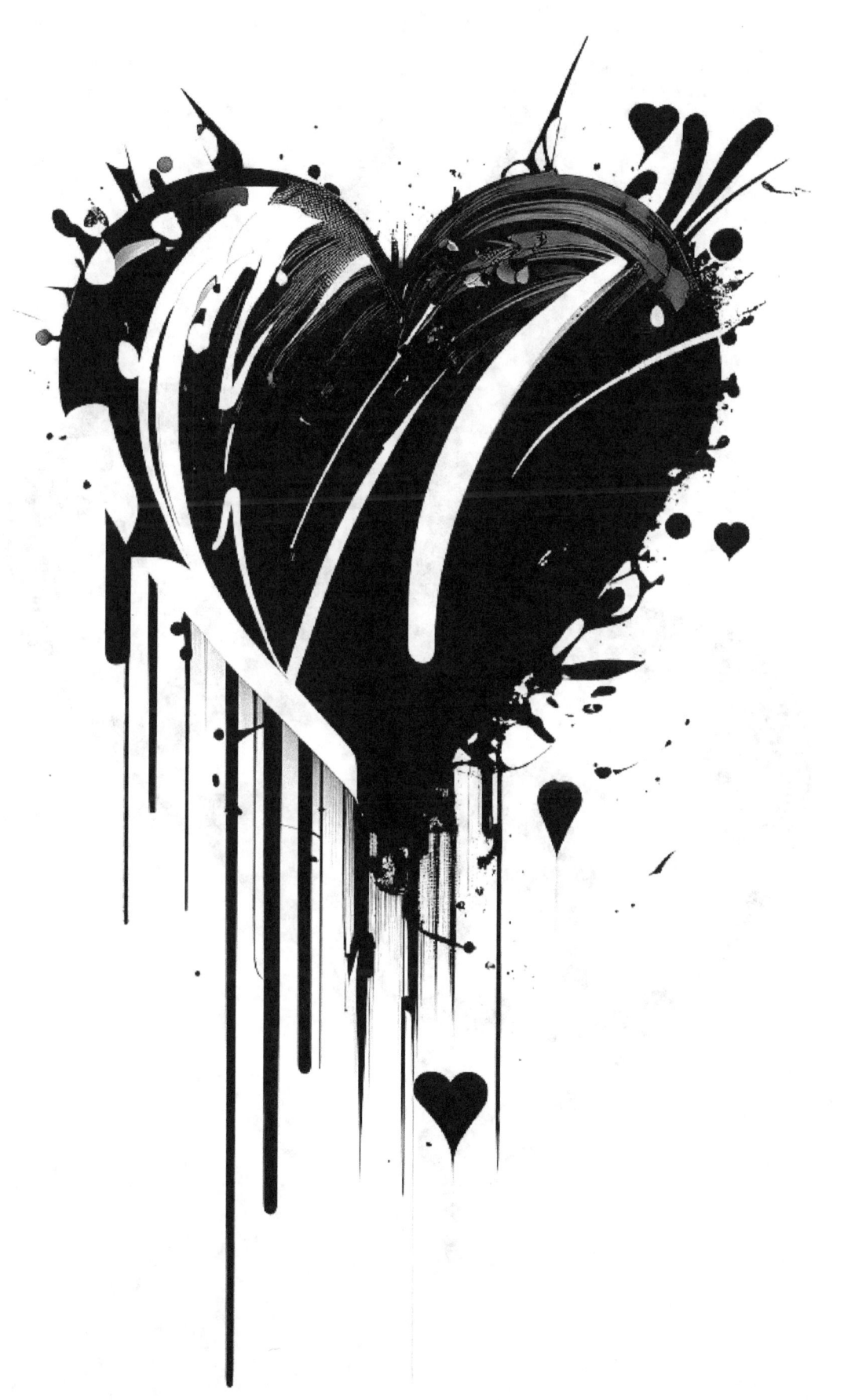

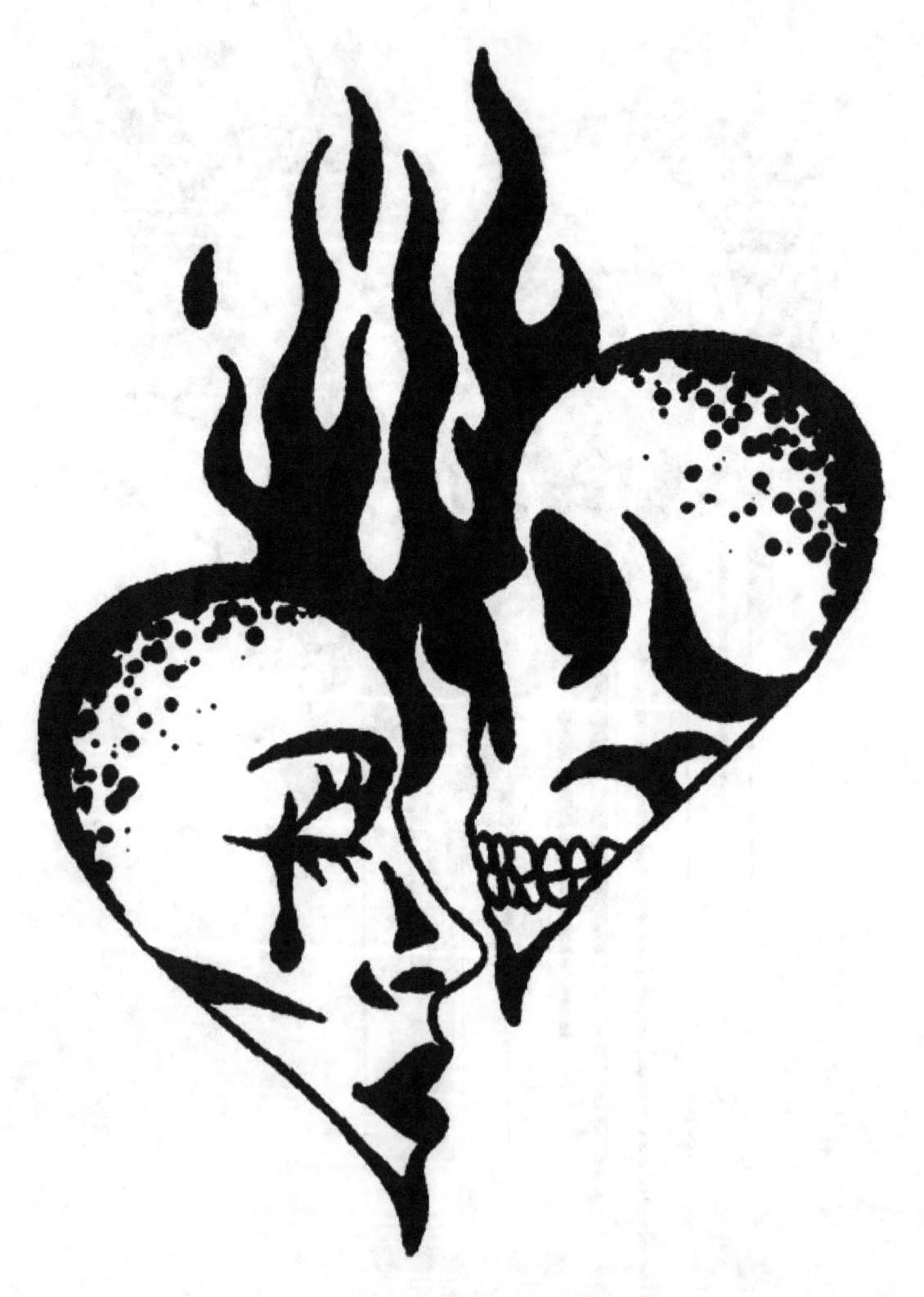

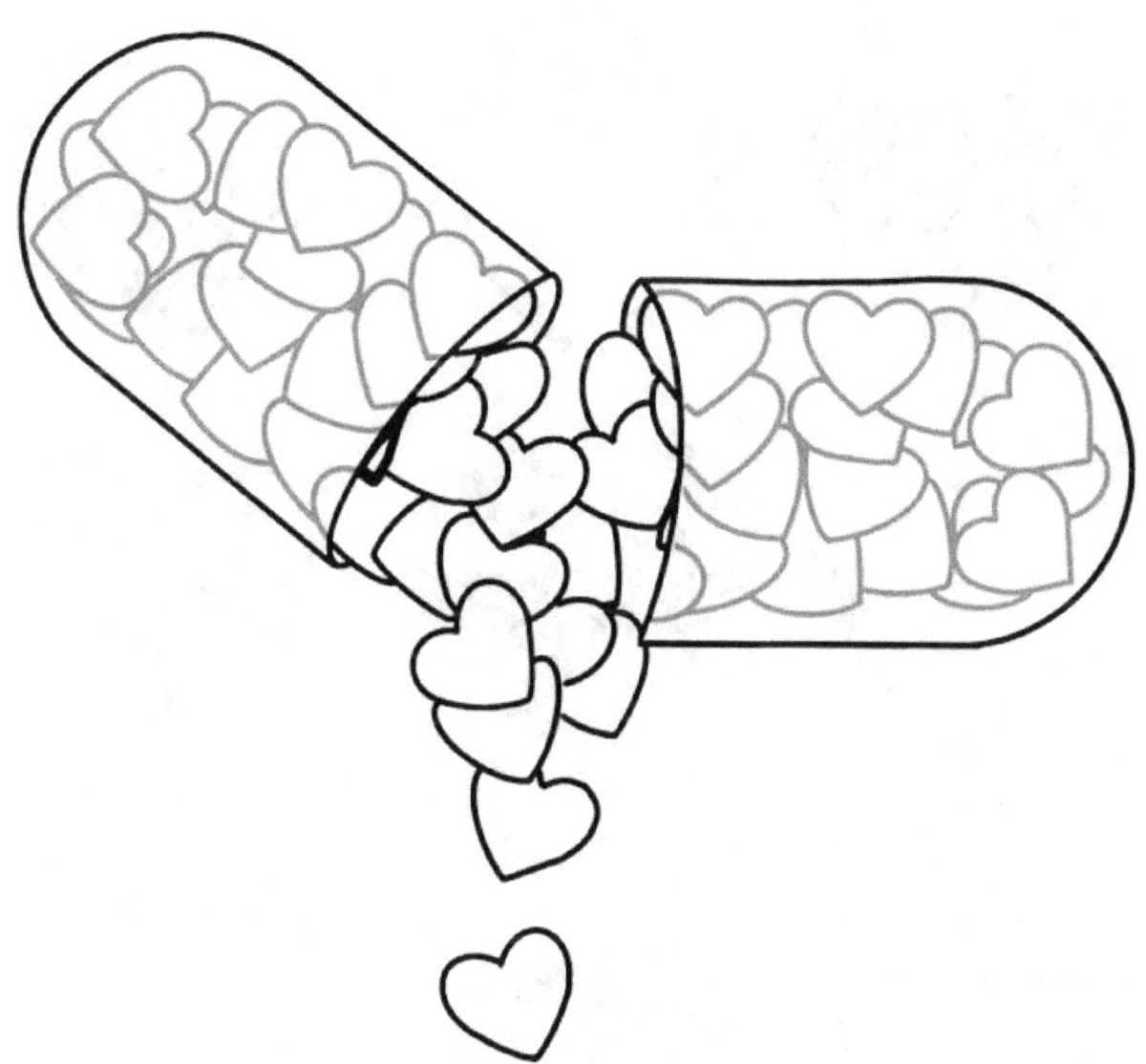

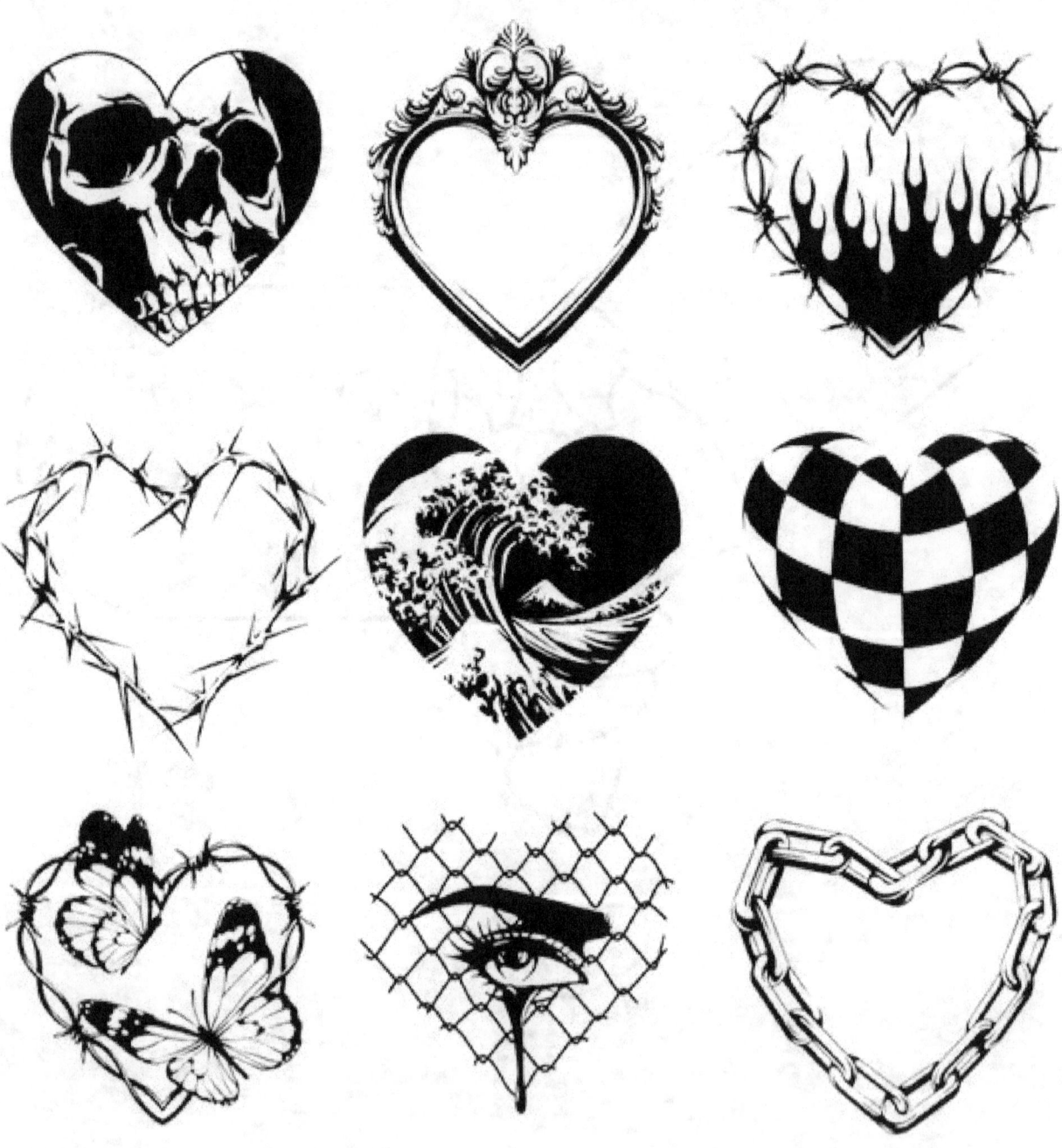

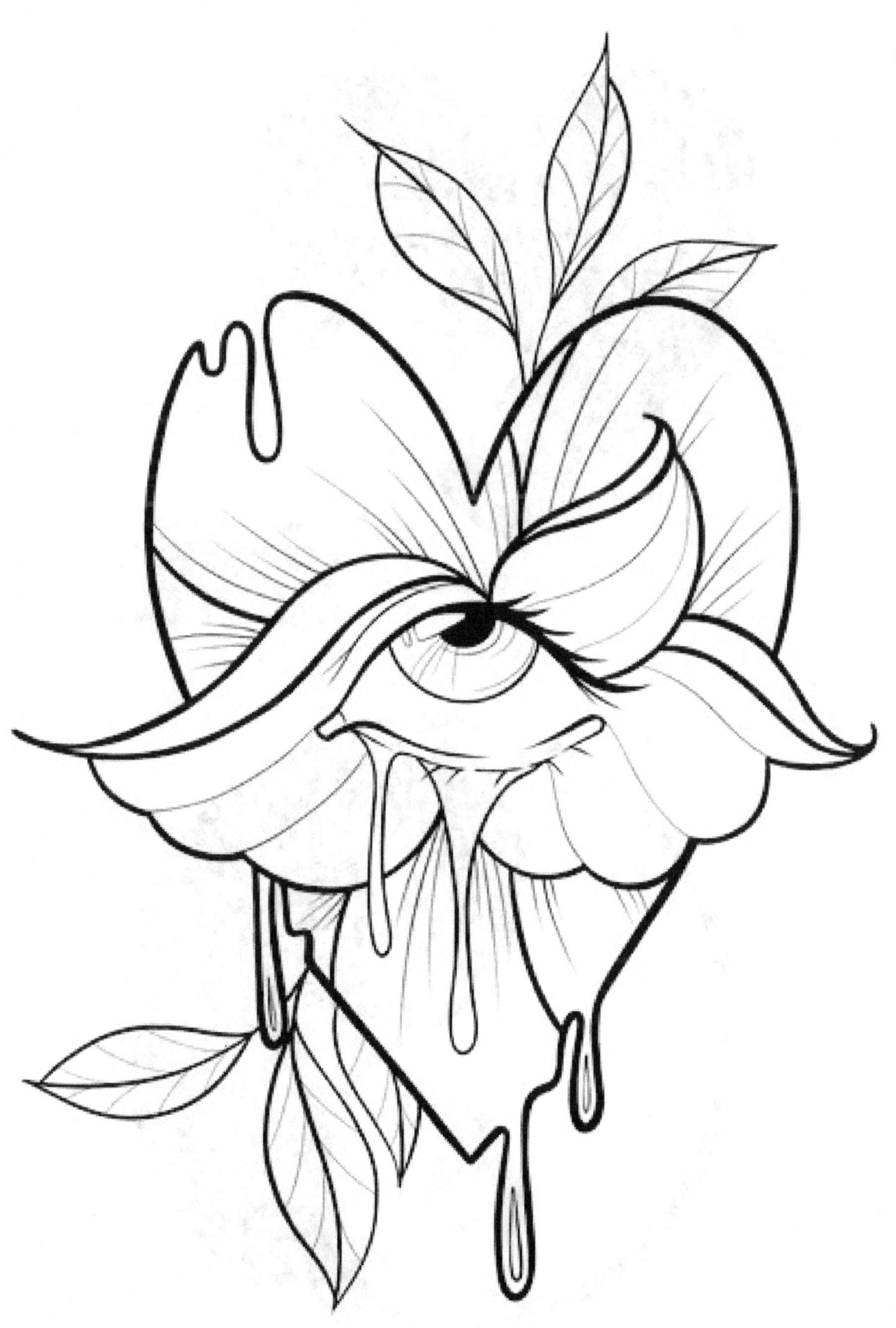

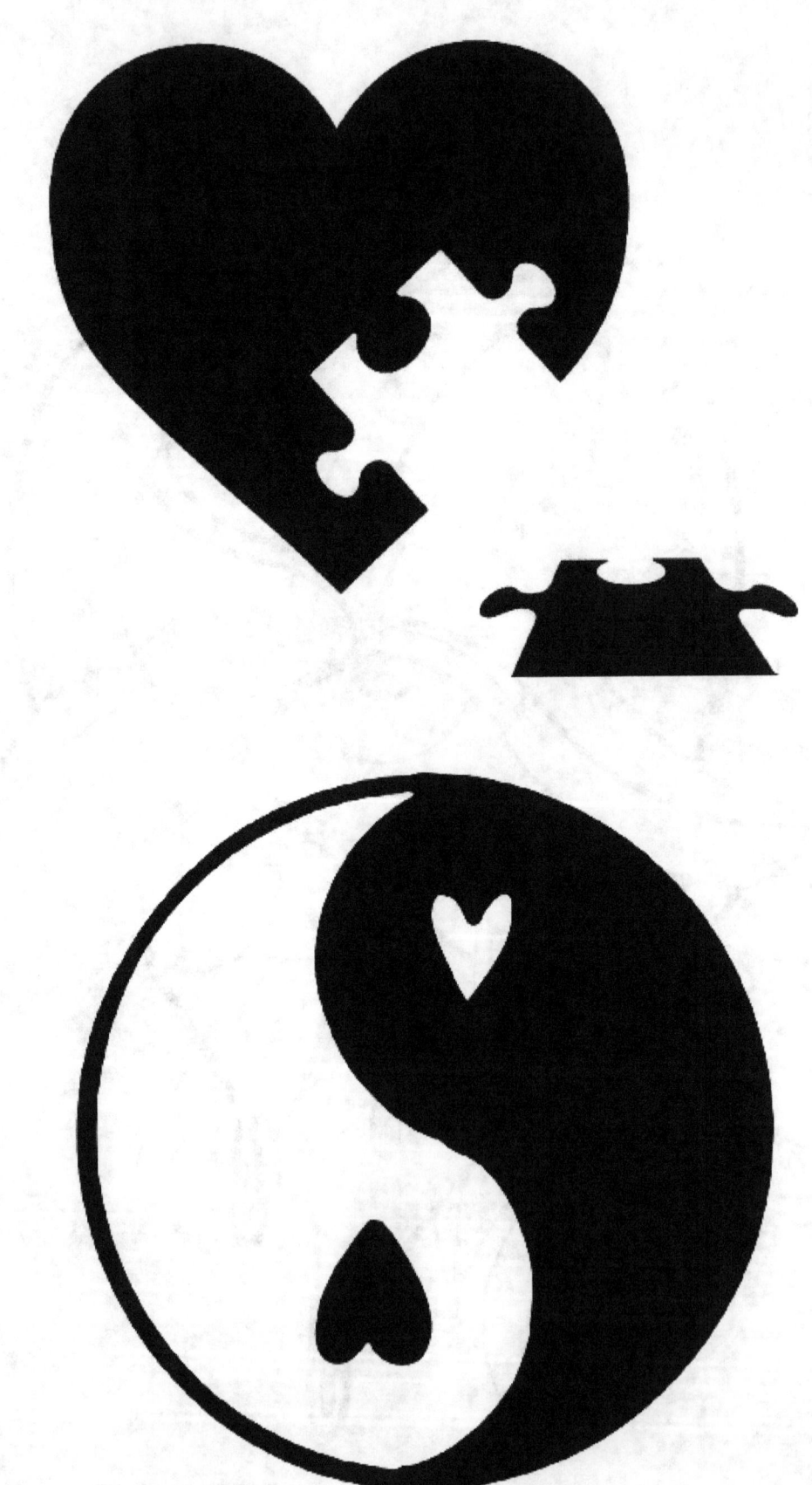

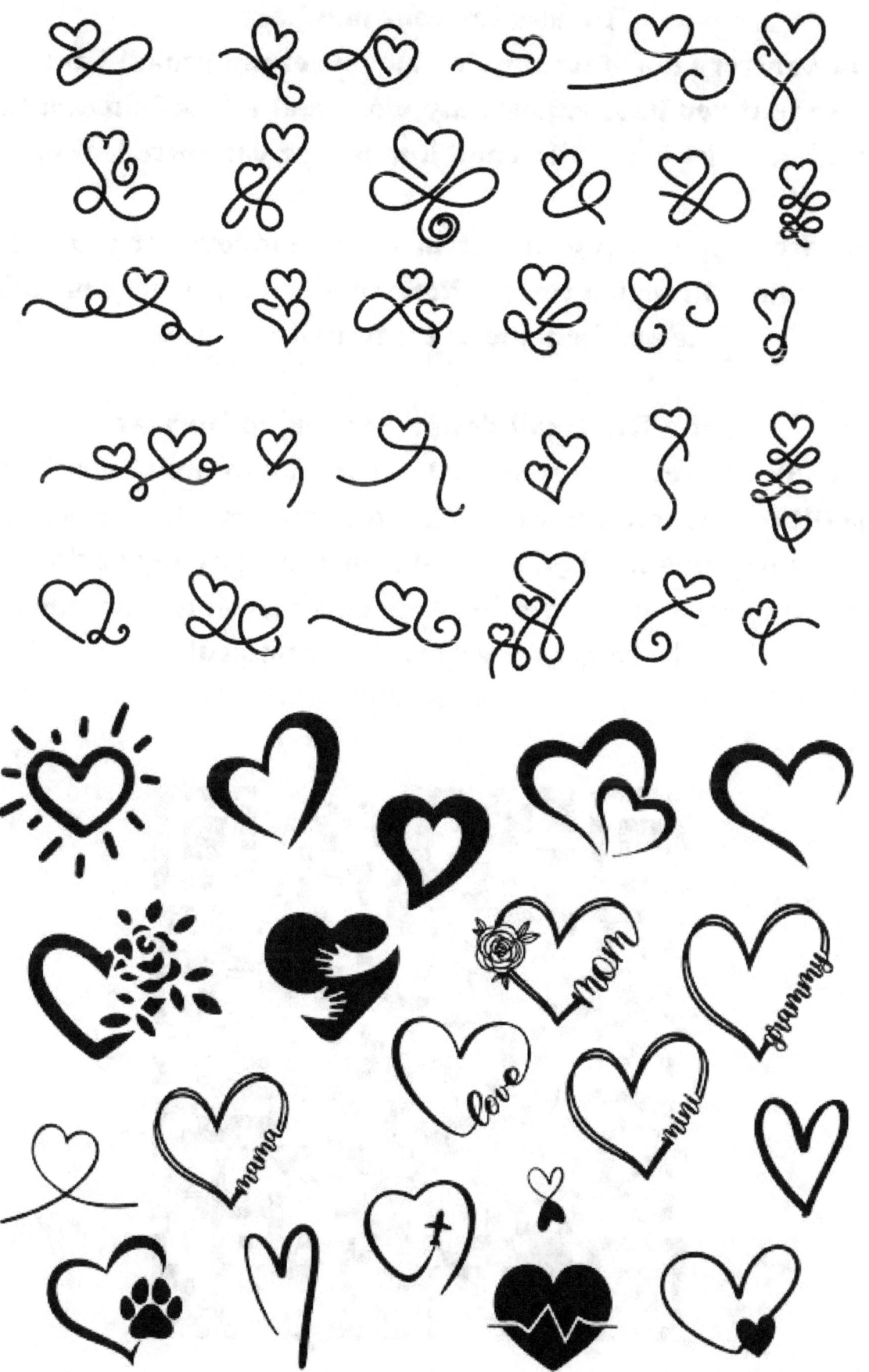

Thanks for your purchase

Thank you very much for purchasing one of my books! I am glad to know that you have enjoyed my work and I hope that you have found in it the inspiration and knowledge you were looking for.

If you are happy with your purchase, I would love for you to share your opinion through a review. Your comments are very valuable to me and help me to continually improve.

Get a free small design book in pdf format.
To thank you for your support, I would like to invite you to scan the QR code where you can access the free download. I hope you enjoy this little gift and continue to enjoy my posts.
Thank you very much again for your purchase and your time! I will be happy to receive your comments.
Sincerely.

www.ingramcontent.com/pod-product-compliance
Lightning Source LLC
Chambersburg PA
CBHW082238220526
45479CB00005B/1268